LOOKING AT

EUROPEAN CERAMICS

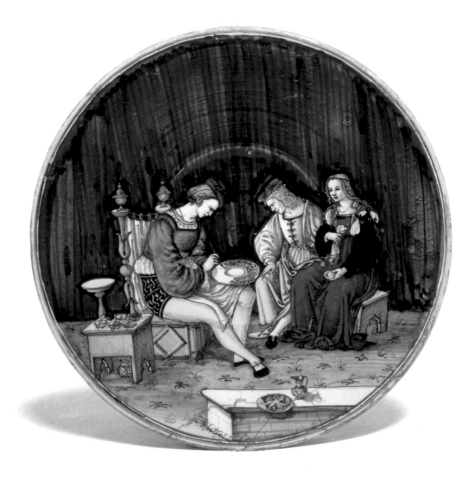

LOOKING AT
EUROPEAN CERAMICS

A GUIDE TO TECHNICAL TERMS

David Harris Cohen and Catherine Hess

THE J. PAUL GETTY MUSEUM
in association with
BRITISH MUSEUM PRESS

© 1993 The J. Paul Getty Museum

Published by the
J. Paul Getty Museum
17985 Pacific Coast Highway
Malibu, California 90265-5799
in association with
British Museum Press
A division of
British Museum
Publications Ltd
46 Bloomsbury Street, London
WC1B 3QQ

At the J. Paul Getty Museum:
Christopher Hudson, Publisher
Cynthia Newman Bohn, Managing Editor
Andrea P. A. Belloli, Consulting Editor

At the J. Paul Getty Trust Publication Services:
Richard R. Kinney, Director
Deenie Yudell, Design Manager
Karen Schmidt, Production Manager

B+T NO/HN

Library of Congress Cataloging-in-Publication Data

Cohen, David Harris.
 Looking at European ceramics : a guide to technical terms / David
Harris Cohen and Catherine Hess.
 p. cm.
 Includes bibliographical references.
 ISBN 0-89236-216-2
 1. Pottery, European—Terminology. 2. Porcelain, European—
Terminology. I. Hess, Catherine, 1957– . II. J. Paul Getty
Museum. III. Title.
 NK4083.c64 1992
 738'.094—dc20 92-19943
 CIP

British Library Cataloguing in Publication Data
A catalogue record for this book is available from the British Library
ISBN 0-7141-1734-X

Copyright of the illustrations is indicated in the captions by the initials
JPGM (J. Paul Getty Museum), BM (British Museum), or by
the name of the institution owning the work illustrated.

The illustrations from Cipriano Piccolpasso's *Li tre libri dell'arte del
vasaio* are all courtesy of the Board of Trustees of the Victoria and
Albert Museum, London.

Cover (American edition): *One of a Pair of Lidded Vases (Vases à Tête de
Bouc)* (detail). Sèvres manufactory, c. 1768. Soft-paste porcelain;
possibly modeled by Michele-Dorothée Coudray and finished by
Nantier; H: 34.2 cm (13⅞ in.); W: 21.9 cm (8⅝ in.); Diam: 16.8 cm
(6⅝ in.). JPGM, 82.DE.36.1.

Frontispiece: *Plate* depicting a maiolica painter. Cafaggiolo, c. 1510.
Tin-glazed earthenware; Diam: 23.5 cm (9¼ in.). London, Victoria
and Albert Museum 1717-1855.

Cover (British edition): Detail of frontispiece.

FOREWORD

Museum curators and visitors alike often overlook the question of how the works of art on view were created. The aim of this book is to assist the visitor by providing brief definitions of the terms most commonly used by artists and art historians when discussing the manufacture of European ceramics. The definitions in this compact volume—small enough to be carried around the galleries—are meant to aid the visitor in understanding label and catalogue text more completely. They are also intended to supply, outside the museum context, a cursory understanding of the techniques involved in producing earthenware, stoneware, and porcelain works of art.

The ceramics field is vast, encompassing objects produced all over the world and since prehistory. This being so, the terms in the book have been limited to reflect the strengths of the collections of the two institutions serving as copublishers: the J. Paul Getty Museum in Malibu and the British Museum in London. In other words, the book addresses the subject of European ceramics from roughly the late Middle Ages through the Victorian period. Terms that fall outside this range are included when they directly relate to the European production under examination. For example, a type of Asian porcelain that influenced European practice might be included here to elucidate the latter.

Since this book concentrates on issues of technique, strictly stylistic or historical nomenclature has not been included, nor have the names of artists or centers of production, except in cases where important technical advances can be credited to specific persons or places.

We wish to thank Andrea P. A. Belloli and John Harris of the Getty Museum's Department of Publications for their counsel and diligence in developing and editing this project. We are also greatly indebted to Aileen Dawson, Curator in the Department of Medieval and Later Antiquities at the British Museum, for her advice and assistance in tracking down illustrative examples at her museum and for her suggestions pertaining to the text. The insights of Alan Caiger-Smith, Leopold Foulem, and Paul Mathieu, ceramists well versed in the technical procedures here

under scrutiny, have also been invaluable, particularly to a couple of museum types like ourselves. Final thanks are owed to Peter Fusco and Gillian Wilson, curators at the Getty Museum in the Department of Sculpture and Works of Art and the Department of Decorative Arts, for their support and encouragement.

<div align="right">David Harris Cohen

Catherine Hess</div>

I am very sorry to report that my friend and colleague David Harris Cohen died while *Looking at European Ceramics* was still in production. I think he would have been pleased with the book in its published form, which everywhere reflects his knowledge and love of the decorative arts.

<div align="right">C. H.</div>

Note Words printed in SMALL CAPITALS refer to other entries in the book. Synonymous terms appear in parentheses.

ALUMINA
(ALUMINUM OXIDE)

REFRACTORY material in GLAZES that enhances durability, reduces crystallization, and increases viscosity of the glazes in the molten state. Alumina can be added to a glaze in the form of a powder or—because it is an ingredient of all clays—it can enter the glaze from the clay body during FIRING.

BANDING WHEEL

Small turntable that allows a ceramist to work on all sides of an object without having to handle and potentially damage it. Commonly used to rotate a vessel so that horizontal bands can be painted around the piece.

BAT

In pottery, indicates a variety of flat surfaces, including:

Flat disk, which can be attached to and detached from the wheel head, allowing the wet piece mounted on the disk to be easily and safely removed from the POTTER'S WHEEL.

Shelf tile, on which objects are placed in the KILN. These tiles and other kiln fittings can be painted with a so-called *bat wash*, composed of REFRACTORY material suspended in water, to prevent fired objects from sticking to them at high temperatures.

Slab of soft clay, which potters use to form plates and other flatware on convex molds attached to the head of the potter's wheel. In the eighteenth century, with the invention of the JIGGER and the JOLLY, PORCELAIN factories began to use bats of clay to

BAT
Cipriano Piccolpasso (Italian, 1524–1579). *Bat of Clay* from *Li tre libri dell'arte del vasaio* (1557), fol. 17v.

The bat (B) has been cut from the round cake of clay (A) by the wire stretched between two boards of the desired thickness.

quickly produce large quantities of flatware and hollow ware.

Bat printing, first used in the mid-eighteenth century, is one method of transferring prints onto ceramic surfaces. It employs flexible sheets of gelatin or glue rather than the more traditional paper.

BÉRAIN MOTIFS

Decoration named after the French engraver and designer Jean I Bérain (1639/40–1711), whose approximately 300 ornamental prints were instrumental in disseminating this popular style. It is characterized by an architectural framework of bandwork (strapwork) with capitals, pilasters, balustrades and urns, baldachins, rinceaux, garlands, swags, and stylized foliage inhabited by putti, classical gods and goddesses, and satyrs and herms. Bérain popularized this light and airy decoration, which was used on interior wall panels, ceilings, furniture, and ceramics. His

BÉRAIN MOTIFS
Tobacco Jar. French (Moustiers), c. 1723–25. Tin-glazed earthenware, H: 26 cm (12¼ in.). JPGM, 84.DE.917.

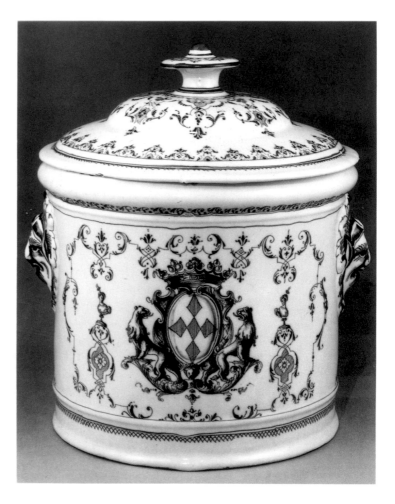

designs always remained symmetrical and therefore should be considered forerunners of the Rococo style rather than examples of it. Other designers, such as Claude Audran (1657–1734), are also known for their work in this style.

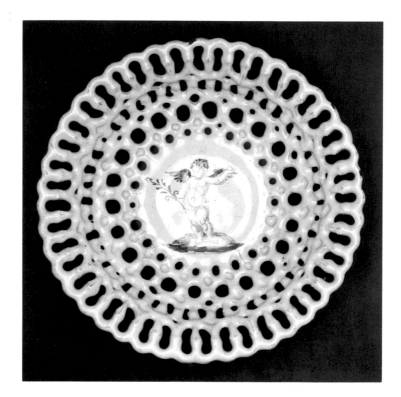

BIANCO DI FAENZA

("WHITEWARE OF FAENZA")

Type of MAIOLICA produced in Faenza from about 1540 through the end of the seventeenth century. Covered with a thick tin GLAZE, Faenza whiteware is often left entirely white (*bianco*), although it is occasionally embellished with single figures or emblems in the popular *compendiario* ("sketchy") style of the period. This decoration reflects the sixteenth-century taste for looser, simpler designs that emphasize rather than obscure the elaborate shapes of the objects themselves. *Bianchi di Faenza* also responded to the increasing need for more efficient and rapid production of ceramics in an expanding international market. Faenza whiteware was so widely exported throughout Europe in the sixteenth century that the French form of the town's name— *faïence*—became synonymous with tin-glazed EARTHENWARE in general.

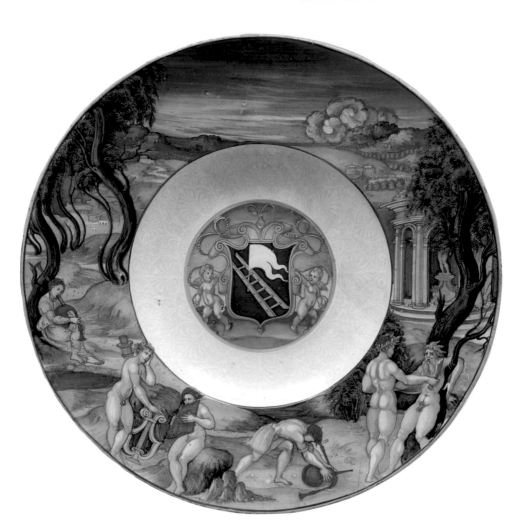

BIANCO SOPRA BIANCO

Nicola (di Gabriele Sbraghe) da Urbino (Italian, c. 1480–1537/38). *Armorial Plate with "The Flaying of Marsyas."*
Urbino, mid-1520s. Tin-glazed earthenware, Diam: 41.4 cm (16⁵⁄₁₆ in.). JPGM, 84.DE.117.
Bianco sopra bianco designs embellish the area between the central medallion
with its coat of arms and the narrative scene around the wide rim.

BIANCO SOPRA BIANCO
("WHITE ON WHITE")

MAIOLICA decoration developed in such central Italian cities as
Castel Durante, Faenza, and Urbino in the first decades of the six-
teenth century. *Bianco sopra bianco* designs feature delicate and
symmetrically placed arabesques and foliage painted in pure,
opaque white pigment against a slightly grayish- or bluish-white
GLAZE ground. These patterns often appear on the wall of a plate
to set off the more colorful grotesques or narrative scenes of the
rim and central medallion. Thanks to the wide export of central
Italian ceramics, *bianco sopra bianco* decoration became popular on
eighteenth-century German, English, Dutch, French, and Scandi-
navian pottery.

BISCUIT

The first FIRING of clay. Translated from the French, the term literally means "twice fired," since the FRIT for soft-paste PORCELAIN was also fired. Occasionally porcelain produced by this first firing is left unglazed and undecorated. Its generally matte white surface, resembling marble or even the spun sugar used to make table ornaments, might have been the reason for its first use in the 1750s at the porcelain manufactory at Vincennes, where it was usually reserved for small sculpture. Its widespread appeal during the eighteenth century caused it to be made in many European factories, such as the Fabbrica Reale in Naples and the Derby factory in England. It remained popular into the nineteenth century. In 1844, the Copeland factory in England introduced *parian ware*, which also resembled white statuary marble. It too was generally used for sculpture, though occasionally more functional objects were produced. Some parian ware was colored to resemble natural stones, such as green for malachite and pinkish white for marble.

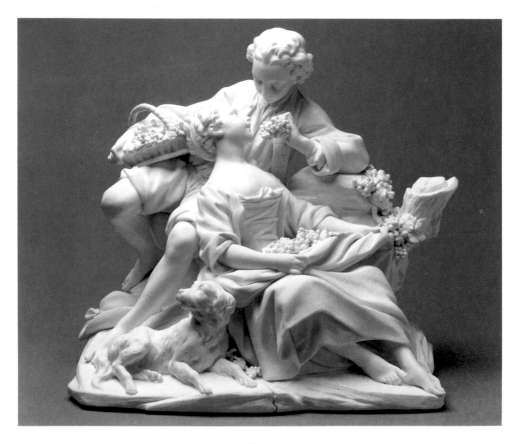

BISCUIT
The Grape Eaters. French (Vincennes), c. 1752. Soft-paste porcelain, H: 22.9 cm (9 in.). JPGM, 70.DE.98.1-.2.

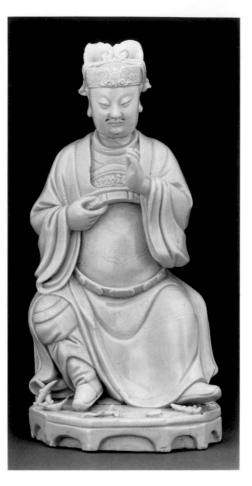

BLANC DE CHINE
Figure of Cai Shen (God of Wealth). Southeast Chinese (Fujian-Dehua ware), Ming dynasty; mark datable to 1610. Hard-paste porcelain, H: 26.5 cm (10½ in.). BM, OA 1930, 11-13, 1.

BLANC DE CHINE

("CHINESE WHITEWARE")

French name given in the eighteenth century to unpainted white-glazed Chinese PORCELAIN made in the factories at Dehua in Fujian province in southeastern China. Though produced as early as the Song dynasty (960–1279), most extant examples date from the Qing dynasty (which began in 1644) and later. Small statuettes were generally produced, the most popular being the Buddhist goddess Guan Yin depicted with flowing robes.

A great deal of blanc de chine was imported into Europe during the seventeenth and eighteenth centuries. It was tremendously influential and was copied by many European factories, such as Mennecy and Saint-Cloud in France and Bow and Chelsea in England.

BLISTERING

Small broken bubbles on the GLAZE surface, caused most often when a piece is overfired or when the glaze is applied too thickly.

BOLE

Fine, smooth clay whose high iron oxide content gives it a tomato-red color. The addition of water creates a thick liquid impasto that is used as a pigment on EARTHENWARE; when fired, it stands out slightly in relief from the glazed surface. This clay is often called *Armenian bole* because it was originally found in the eastern Mediterranean, although it is also found in Tuscany and elsewhere. Bole is particularly associated with a type of decoration on Turkish IZNIK pottery dating to the last quarter of the sixteenth century.

BONE CHINA

See PORCELAIN.

BÖTTGER RED

See STONEWARE.

CALCINATION
Cipriano Picccolpasso
(Italian, 1524–1579).
Calcination Kiln and Mill
from *Li tre libri dell'arte del
vasaio* (1557), fol. 27v, 36v.

CALCINATION

(FRITTING)

Process by which substances are roasted or partially fused in a KILN to drive off any volatile material and amalgamate the various ingredients. After calcination, the mixture is ground to a powder before use.

CAMAÏEU

Painted decoration resembling a cameo (French, *camaïeu*), done in monochrome colors. It is not known exactly where the technique was first used, but it has been popular in Europe since the eighteenth century. At the Vincennes/SÈVRES porcelain manufactory, for instance, putti, garlands, birds, and landscapes were painted in blue, green, carmine, or mauve.

CAMAÏEU

Potpourri Vase (one of a pair). French (Vincennes), c. 1775. Soft-paste porcelain, H: 25.5 cm (10 in.). JPGM, 84.DE.3.

The pink camaïeu decoration of a winged putto on clouds embellishes the white reserve panel, which is surrounded by a dark *bleu lapis* ground.

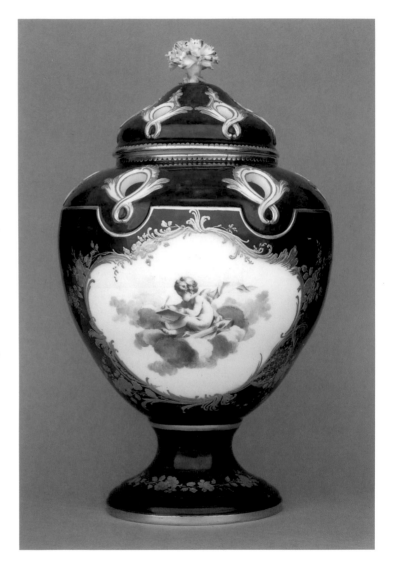

CANEWARE

See STONEWARE.

CHATTER MARKS

Series of shallow grooves cut into a vessel on the POTTER'S WHEEL by an incorrectly held or dull trimming tool.

CHEESE HARD	Raw clay state in which some moisture has evaporated but the clay is still moist and soft enough to be worked.
CHINA	Commonly used term that broadly and inexactly refers to any ceramic tableware. The term derives from *porcelain from China*, a phrase used since the fifteenth century, when vessels made of Chinese PORCELAIN began arriving in the West in large numbers.
CHINOISERIE	Term generally used to describe the European interpretation of Middle and Far Eastern shapes or decorative motifs. Although the word was not used before the nineteenth century, it generally

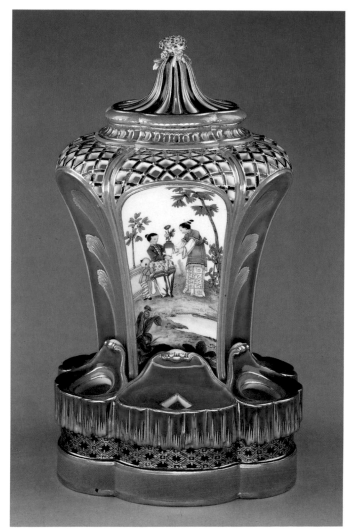

CHINOISERIE
Vase (one of a pair). French (Sèvres), c. 1760. Soft-paste porcelain, H: 29.8 cm (11¼ in.). JPGM, 78.DE.358.

The chinoiserie embellishment of this vase depicts Asian figures in a landscape.

refers to works produced from the sixteenth through the eighteenth centuries in Europe or to those objects made for the European market during this same period.

By the seventeenth century, Asian and Middle Eastern objects began reaching Europe in considerable numbers, though they continued to be appreciated as great rarities. The imports came from many disparate areas of Asia, thereby giving a bewilderingly varied impression of the work being produced on that continent. Exoticism of any kind and origin became extremely fashionable during this period, and European craftsmen continually mixed such "exotic" designs or ideas—which had originated in different Middle Eastern and Asian centers or countries—with European styles. The resulting objects or designs would have been unrecognizable to Asians themselves. This vogue reached its height with the early-nineteenth-century designs for the Brighton Pavilion, the seaside retreat of the Prince Regent, in which bizarre combinations of exotic styles were lavishly employed.

CLAY

Earth composed mainly of hydrated silicates of aluminum that is formed by the decomposition of feldspathic rocks. Moist clays are naturally plastic, or malleable, but as water evaporates or is added the clay becomes more or less rigid. When exposed to temperatures of 450 degrees Centigrade or more, clays become permanently hard.

Primary or **residual** clays are found where they have been formed by nature. They include ingredients that can be added to so-called potter's clays—i.e., those used for ceramic production—to impart their particular properties. KAOLIN, for example, adds whiteness and hardness to a clay body and is an essential component of PORCELAIN.

Secondary or **sedimentary** clays are transported by the elements from their place of origin, picking up mineral impurities and organic matter on the way. Some of this gathered mineral and organic material is necessary to give different clays their different qualities, such as colors ranging from red to buff to white, and varying degrees of plasticity, fusibility, and shrinkage. Many of the impurities, however, must be extracted to make the clay suitable for ceramic use.

The more wet and plastic the clay, the more it will shrink and the more likely it will become deformed during FIRING. To counteract this tendency, very plastic clays, described as *rich* or *fat*, require the addition of GROG—a coarse material such as ground fireclay, quartz, POTSHERDS, or sand—to make the clay easier to

handle and to help an object hold its shape. Conversely, *lean* or *short* clays are those not malleable enough for handling, which require the addition of fat clays, such as bentonite (a sticky, volcanic primary clay originally found at Fort Benton, Montana) or ball clay (a secondary potter's clay discovered in England), to increase plasticity.

To prepare a natural clay and ensure that it is relatively pure and fine, the clay can be washed using *levigation* (also known as *elutriation* or *sedimentation*), by which process the clay is mixed with water and allowed to stand. The liquid is then poured off and sifted to remove the suspended fine clay, and the coarse material that has settled at the bottom is discarded. The now-pure extracted clay must be partly dried and WEDGED to create a homogenous mass.

CLAY
Cipriano Piccolpasso (Italian, 1524–1579). *Gathering Clay from a Riverbed and from Pits Where There Are No Rivers* from *Li tre libri dell'arte del vasaio* (1557), fols. 2r, 3r.

Above, workmen at the lower left collect clay from a riverbed; below, a workman gathers clay from hand-dug pits where it has accumulated after a rainstorm.

Already completed ceramics the decoration of which has been supplemented at a later date or which have been given a completely new decoration. This was often done to make the piece more saleable or to change its aesthetic appeal and was a relatively common practice with Asian ceramics that had simple underglaze blue designs and with seconds or rejected pieces. Colored enamels and GILDING were added and then the piece was generally refired to fix the new designs. Refiring was not necessary when COLD COLORS were used.

The Dutch, who were major importers of Asian ceramics, were among the first to use this technique. It was later practiced by most other ceramic-producing countries in Europe. In Germany, the HAUSMALERS were responsible for a good deal of the decoration added to blue-and-white wares. One of the most famous was Ignaz Preissler of Breslau (born 1676), who used both imported Asian ceramics and the more local wares produced by MEISSEN. He excelled in the SCHWARZLOT technique of decoration.

During the eighteenth century, SÈVRES continually sold off its stock of undecorated seconds (*rebuts blancs*), which were then generally overpainted (*surdécoré*) by outside artists. In 1804, this factory sold its entire stock of undecorated soft-paste PORCELAIN, which was subsequently decorated and is easily recognizable as clobbered ware.

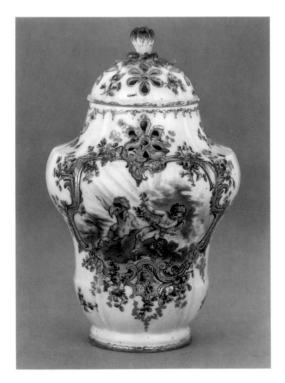

CLOBBERED WARE
Vase and Cover. French (Mennecy), c. 1740–50 (probably redecorated mid-19th century). Soft-paste porcelain, H: 13.6 cm (5⅜ in.). BM, MLA Franks 358.

COILING

One of the earliest methods of forming ceramic vessels. The potter rolls long coils of soft clay that are placed on top of one another on a flat base, creating a hollow form. Coils of different lengths produce vessels of varying dimensions. The potter works the coils together, shaping the vessel and smoothing out the interior and exterior. This method is still used today to create very large pots that would be unmanageable on the POTTER'S WHEEL. See also THROWING.

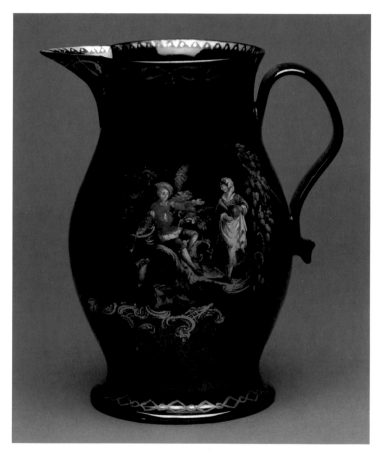

COLD COLORS

Pitcher. English (Staffordshire), c. 1760–65. Earthenware with black glaze, H: 20.8 cm (8¾₆ in.); W (incl. handle): 17.7 cm (7 in.). BM, MLA Hobson (1903), O 2.

COLD COLORS

Oil-based or lacquer colors painted on ceramics without FIRING, thus making decorated pieces with bright colors easier to produce. The technique was used, for example, on Böttger red STONEWARE produced at MEISSEN. The colors, though, were subject to wear and therefore often did not last. The technique was used until approximately the mid-nineteenth century, when fired enamels replaced these more fugitive colors. See also MEISSEN PORCELAIN MANUFACTORY.

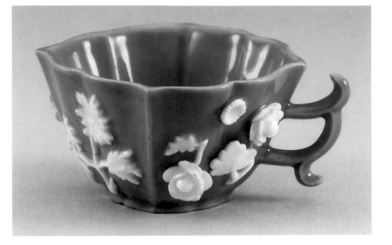

COLORED BODY

Clay to which a coloring agent—such as a METALLIC OXIDE—has been added, thus giving the resulting fired ceramic the desired hue. The ceramist Johann Gregor Höroldt (1696–1775) experimented with this technique at MEISSEN, though it was left to Josiah WEDGWOOD to popularize the technique on such materials as creamware and jasperware.

COLORS

Pigments derived from METALLIC OXIDES and used to decorate ceramic bodies. Before the twentieth century, when pure mineral oxides became commercially available, the most commonly used oxides included cobalt for blue, copper for green, iron for brown, manganese for purple, antimony for yellow, and various compounds for red and black. Mineral ores containing the desired

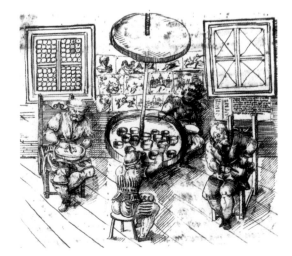

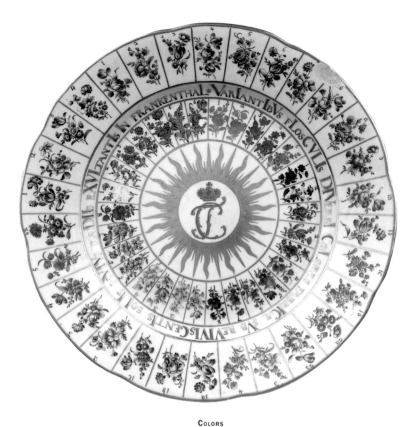

COLORS

Plate. German (Frankenthal), 1775. Hard-paste porcelain, Diam: 25.3 cm (9¹⁵⁄₁₆ in.). BM, MLA Franks 182.
This plate displays sample colors that were available at the Frankenthal factory.

oxides were milled and calcined with a FLUX, often repeatedly, to produce smooth-firing ceramic colors.

Metal-oxide pigments, often grayish or pale when raw, develop into brilliant colors when fired. They are called *underglaze* colors when painted under the glaze directly on the BISCUIT ware and *overglaze* or *enamel* colors when painted onto the surface of the fired glaze and then fired again. So-called *in-glaze* pigments are painted on MAIOLICA and fired with the raw glaze, becoming fused into, rather than under or over, the glaze. The range of enamel colors is greater than in-glaze or underglaze colors since enamels require only a low-temperature firing to cause them to adhere to the softened glaze; the high-temperature firing of in-glaze or underglaze pigments can often burn away part or all of the colored oxides.

CONE

Pyrometric indicator invented by Hermann August Seger (1839–1893), a German ceramic chemist. Ceramic materials in the shape

of a small pyramidal peg begin to melt when a predetermined temperature is reached. Potters view these cones through the KILN spy-hole during FIRING to gauge the level of heat within. Other objects that are used to show the effects of temperature over time include bars that sag and rings that shrink.

Before the invention of cones and other pyroscopes, potters judged the temperature in the kiln simply by looking through an opening in the kiln wall to assess the temperature of the wares by their color.

COPPA AMATORIA

(COPPA D'AMORE)

MAIOLICA plate, especially popular in Castel Durante, Pesaro, and Urbino in the early sixteenth century, decorated with declarations or allegories of love and made for presentation to a lover or betrothed. These *coppe* are sometimes called *belle donne* ("beautiful women") plates—or simply *belle*—when they display the portrait

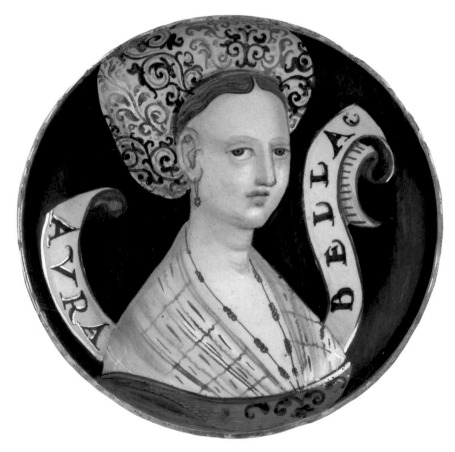

COPPA AMATORIA

Dish on Low Foot. Italian (Gubbio or possibly Urbino district; lustered in the workshop of Maestro Giorgio, Gubbio), 1530. Tin-glazed earthenware, Diam: 22.2 cm (8¾ in.). BM, MLA 1851, 12-1, 19.

busts of loved ones, most often young women. They frequently include a banderole inscribed with an amatory phrase, the name of the sitter, or a classicized name (possibly a literary allusion), and a word of praise such as *bella* (beautiful), *pulita* (pure), or *diva* (divine). So-called "love cups" also include a type of sweetmeat dish for use in nuptial ceremonies and called a *gamelio* (from the Greek *gamos*, "bride"), as well as plates painted with portrait busts of famous men or women from antiquity, usually shown in armor, who may have served as exemplars of virtue.

CRACKLE

(**FRENCH**, *CRAQUELURE*)

As opposed to accidental CRAZING, a series of deliberately induced GLAZE cracks of varying size, created for a decorative effect. These cracks are generally produced by the different shrinkage rates of the glaze and the ceramic body. The Chinese were particularly fond of this technique, which they began using during the Song dynasty (960–1280) and again during the revival of the Song style during the eighteenth century. Very often a stain was used in the crackle to make the pattern more pronounced. These vases were highly prized by European collectors during the eighteenth century and were often mounted in gilt bronze.

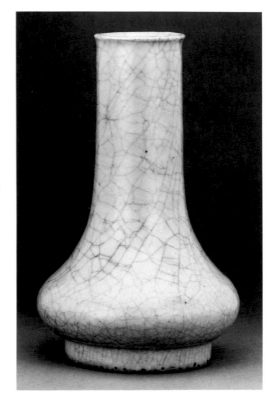

CRACKLE
Vase. Chinese (Zhejiang Longquan kilns), Southern Song dynasty, 12th–13th century. Stoneware, H: 23.4 cm (9¼ in.). BM, OA 1936, 10-12, 66.

CRAWLING

Dish. Italian (Cafaggiolo), c. 1535–40. Tin-glazed earthenware, Diam: 48 cm (18⅞ in.). BM, MLA AF 3189.

The GLAZE and painted decoration have pulled away from the surface of the piece above during FIRING, exposing the layer of white SLIP visible in the detail at right.

CRAWLING

Defect characterized by the GLAZE pulling back from the clay body during FIRING, leaving an unglazed area. Glazes can crawl away from a sharp edge or crack in the piece or from an area where SLIP or other decoration meets the plain clay body. A type of crawling called *beading* occurs when the glaze rolls onto itself and melts into separate drops. The defect is called *lifting* when the glaze is applied over wet clay, dust, or grease and becomes sufficiently loosened from the surface to crawl when it melts. Although crawling can take place on all types of ware, it occurs most often with glazes containing oxides such as zinc or tin that cause the glaze surface to shrink proportionately more than the clay body. This uneven shrinkage increases surface tension and causes the glaze to pull together during firing, leaving open cracks or gaps in the glaze.

CRAZING	GLAZE defect resulting in a network of fine surface cracks. Crazing occurs after FIRING when, as the vessel cools, the glaze contracts more than the clay body it covers. Crazing can also result if a glaze is not elastic enough to withstand contraction and expansion during rapid changes of temperature in everyday use, such as cooking. Crazing is a particular problem on EARTHENWARE vessels since it breaks up an impervious glaze layer into cracks that catch dirt and cause the porous clay beneath to absorb moisture. Wares that fuse when fired, such as PORCELAIN and STONEWARE, can be deliberately crazed for decorative effect, in which case crazing is called CRACKLE or *craquelure*.
CREAMWARE	See EARTHENWARE.
CUENCA (SPANISH, "CELL")	Decorative technique used on Spanish tiles and, less often, on vessels from the mid-fifteenth century, by which a pattern is impressed into the clay, leaving ridges between the areas of colored GLAZES to prevent the glazes from running together during FIRING.

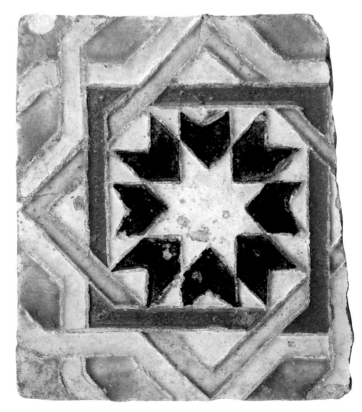

CUENCA
Tile. Spanish (Valencia), late 15th century (?). Tin-glazed earthenware, 13.9 × 12 cm (5⁷⁄₁₆ × 4¾ in.). BM, MLA 1853, 4-1, 64.

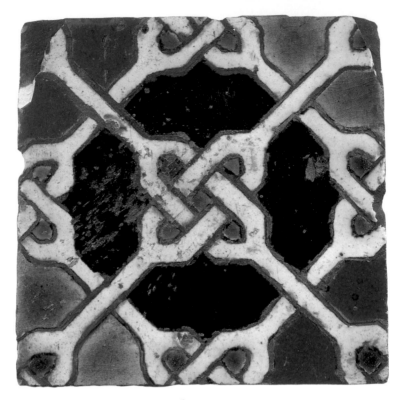

CUERDA SECA

(SPANISH, "DRY CORD")

Type of decoration adopted by Spanish potters about 1500 from Near Eastern craftsmen for use mainly on tiles (*azulejos*). The outline of a design is drawn with a greasy material mixed with manganese oxide that, when fired in the KILN, keeps separate the different areas of colored GLAZES. This technique was superseded by CUENCA decoration.

DELFTWARE

See EARTHENWARE.

DRY-BODIED WARE

See STONEWARE.

DRUG JAR

Container, made of EARTHENWARE in the Renaissance and later of PORCELAIN and creamware, used to store drugs, including pigments, scents, cosmetics, sweetmeats, spices, dyes, and herbs, as well as pharmaceuticals in private and public pharmacies and druggists' shops. The rise of this ceramic form coincided not only with the establishment of monastic and courtly pharmacies after successive plagues in the late Middle Ages but also with the increased interest in alchemy during the Renaissance. It remained

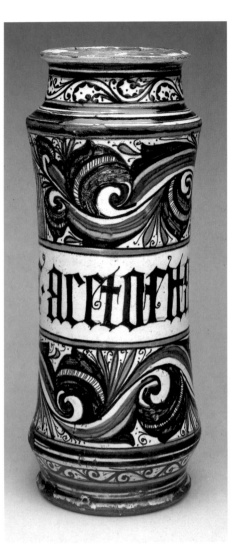

DRUG JAR
Cylindrical Drug Jar
(Albarello). Italian
(Faenza), c. 1480. Tin-
glazed earthenware,
H: 31.5 cm (12⅜ in.); max.
Diam: 12.4 cm (4⅞ in.).
JPGM, 84.DE.104.

in use well into the nineteenth century in most European
countries.

Drug-jar types include the *wet-drug jar* (Italian, *idria*; Spanish,
botijo; French, *chevrette*; German, *Apothekekanne*) for liquid syrups
and electuaries (mixtures of medicinal powders and honey), which
is most often ovoid with a long spout. A *dry-drug jar* for solid med-
icines and ointments is commonly ovoid (Italian, *orciuolo*),
baluster-shaped, or cylindrical (Italian of Arabic origin, *albarello*),
with or without handles. The *albarello* derives from a twelfth-
century Near Eastern form based on the shape of a bamboo stalk
section, which an *albarello* resembles, that also served as a drug
container. The *albarello* includes a protruding lip onto which a
parchment or leather cover could be fastened with string. Its

waisted shape ensured that it could be easily removed from a shelf filled with similar vessels. *Pill containers* (Italian, *pilloliere* or *pisside*) typically have a short, bulbous shape with a wide mouth, so that the druggist could easily reach the pills inside.

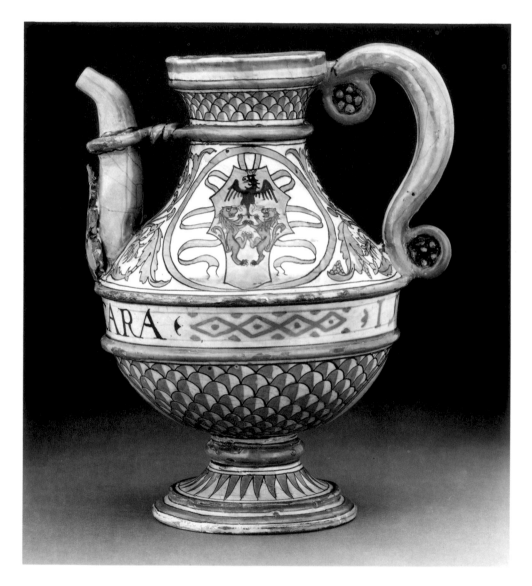

DRUG JAR
Wet-Drug Jar. Italian (Deruta), 1502. Tin-glazed earthenware, H (to rim): 26 cm (10¼ in.).
BM, MLA 1855, 12-1, 57.
This drug jar is painted with yellowish LUSTER.

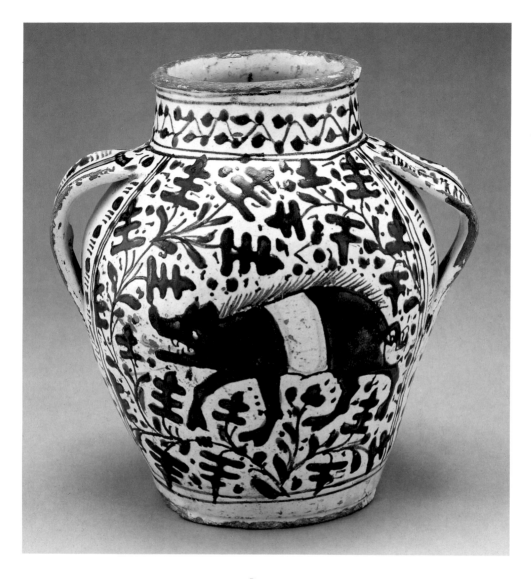

DRUG JAR

Two-Handled Drug Jar (Orciuolo). Italian (Florence), c. 1431. Tin-glazed earthenware,
H: 25 cm (9⅞ in.); max. W: 24.5 cm (9⅝ in.). JPGM, 84.DE.98.

EARTHENWARE Opaque and coarse ceramic ware that is fired at a relatively low
temperature. Since it does not vitrify in the KILN but remains
porous, EARTHENWARE requires glazing for hygienic reasons so
that the clay body does not absorb moisture.

Types of earthenware covered with a lead glaze include:

Creamware (Italian, *terraglia*; French, *faïence fine*; German,
Steingut; also called *Queen's ware* in England), cream-colored ware,
made with calcined flint to whiten, harden, and stabilize the clay

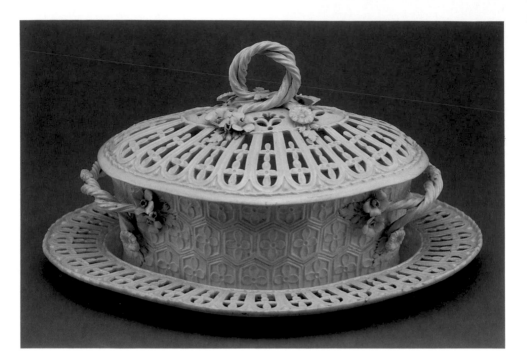

EARTHENWARE: CREAMWARE

Basket with Cover and Stand. English (Staffordshire, Cobridge); signed *John Daniel*, dated 1775. L (of stand):
27.7 cm (10⅞ in.); H (total): 14.6 cm (5¾ in.). BM, MLA Hobson (1903), H 49.

EARTHENWARE: PEARLWARE
Jug. English
(Staffordshire), signed
Sampson Lownds, 1789.
H: 17.7 cm (6¹⁵⁄₁₆ in.);
W (with handle): 14.9 cm
(5⅞ in.). BM, MLA
Hobson (1903), H 63.

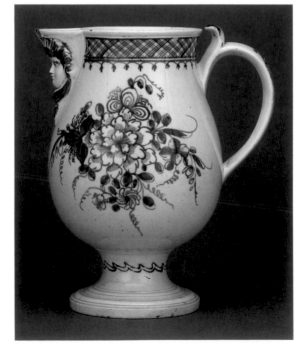

body and then covered with a lead-oxide-based GLAZE. Developed by Josiah WEDGWOOD about 1760 to compete with PORCELAIN, creamware achieved great commercial success throughout Europe, subsequently putting out of business most tin-glazed earthenware factories.

Mezza-maiolica, wares dipped in a light-colored SLIP, painted, and covered with a transparent lead glaze. Before the widespread use of tin glazing in the Renaissance, this technique established a light ground color for painted decoration.

Palissy ware (also called *figulines rustiques* or rustic ware), a ceramic type developed by the French scientist and philosopher Bernard Palissy (1510?–1590) and popular well into the nineteenth century. It is characterized by relief ornament—usually leaves, shells, fish, and small reptiles—colored with lead-oxide pigments and covered with a clear lead glaze. The resulting running-together of the colors during firing seems to imitate the natural river or marsh settings of the relief decoration. Palissy also developed *terre jaspée* (or "jasper earth"), similar to the Whieldon ware (see below) of two centuries later, in which the mingling of lead oxides beneath a clear lead glaze reproduces the appearance of jasper.

Pearlware, earthenware developed by Wedgwood between 1775 and 1779 as an improvement on creamware, closer in appearance to, yet still less expensive than, porcelain. These ceramics include greater proportions of white clay and flint than creamware and their transparent glazes include a trace of cobalt FRIT, rendering the surface a pearly bluish-white.

Saint-Porchaire ware (also called *faïence à niellure* or *niello faïence*), objects made of a fine earthenware clay, usually inspired by metalwork, decorated with delicate, repeating, incised or impressed designs inlaid with different-colored slips. Also called *Henri Deux ware* because these objects were purportedly made during the reign of Henri II in the early sixteenth century.

Sgraffito ware, pottery covered with a light-colored slip through which designs are scratched (*sgraffito*), showing the darker clay body beneath. These wares are often embellished with pigmented, highly fusible lead oxides under a transparent lead glaze.

Whieldon ware, a generic name for cream-colored pottery with a variegated polychrome surface that results from firing metal oxides under a clear lead glaze; now usually referred to as *tortoiseshell ware*. Although thought to have been developed by Thomas Whieldon (1719–1795) of Fenton Vivian, Staffordshire, in the mid-eighteenth century, no secure evidence of Whieldon's production remains despite the recent excavation of his factory. The popular tortoiseshell-like glazing associated with his work was

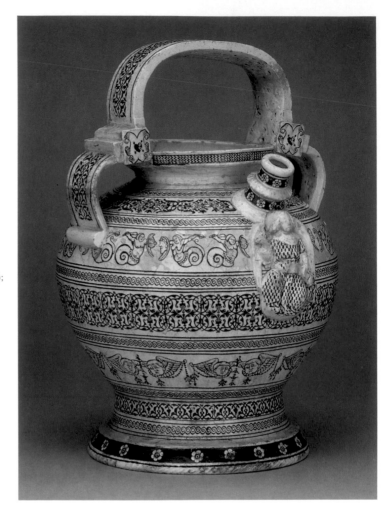

likely to have also been produced in some of the more than one hundred other potteries in the northern Staffordshire area. The intermingled brown, green, blue, purple, and yellow areas on the surface of so-called Whieldon ware result from the oxides melting together in the kiln.

Types of earthenware covered with a tin glaze usually accentuate the pictorial and coloristic qualities of the medium. United by a common decorative technique, tin-glazed earthenwares are generally differentiated by country of origin, usually being called *delftware* in England, *faïence/fayence* in France, Germany, and Holland, and *maiolica* in Italy. The exact use of these closely related terms varies from country to country, and even within the same country.

ENAMEL See COLORS.

ENGINE TURNING

(ENGINE-TURNED DECORATION)

A relief pattern cut on an engine-turned lathe and done while the ceramic is still LEATHER HARD before FIRING. The designs produced are geometric, many varieties of which could be made with the use of a pattern "rosette"; the resulting elaborate patterns are often called *rose-engine turned*. This technique was often used by English potters, notably WEDGWOOD, who is said to have introduced the first engine-turning lathe in Staffordshire.

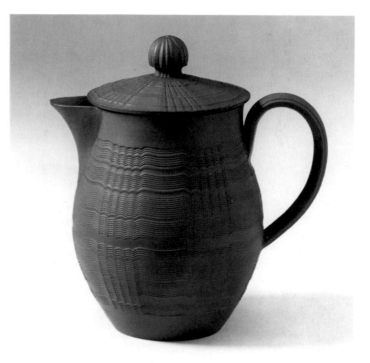

ENGINE TURNING
Milk Jug and Cover. English (attr. to Josiah Wedgwood), 1764–69. Stoneware, H (incl. lid): 12 cm (4¾ in.). BM, MLA Hobson (1903), G 29.

FAÏENCE

See EARTHENWARE.

FELDSPAR

Crystalline mineral found in igneous rocks which are formed by the earth's cooling magmas. Feldspar is one of the most important raw materials used by potters, since it naturally contains SILICA, ALUMINA, and a FLUX. Alone, feldspar can be used as a FRIT, flux, or GLAZE. In 1821, Josiah Spode (1755–1827) added it to a PORCELAIN clay body at his factory in Staffordshire to produce a type of bone china. See also PORCELAIN.

FETTLING

The process of trimming away excess material or unwanted seam marks before FIRING. A fettling knife, also called a potter's knife, is often used in this operation.

FIRE-CRACK

Fire-crack on the underside of a vase from the workshop of Geminiano Cozzi (Italian, active 1764–1812). Venice, 1769. Hybrid soft-paste porcelain. JPGM, 88.DE.9.2.

FIRE-CRACK

Crack in PORCELAIN or STONEWARE that occurs during BISCUIT firing. Fire-cracks most often result when uneven areas of clay absorb and give off heat at different rates during FIRING and cooling, causing unequal stresses that result in splits. Cracks in the clay body can also result from over-rapid heating or cooling in the KILN; this defect is called *dunting*.

Although imperfect pieces (known as WASTERS) are often discarded, in the eighteenth century attempts were occasionally made to save them by GLAZING over the cracks. Fire-cracks are noticeably wider at one end than the other, making them distinguishable from cracks caused by impact, in which case the two sides are equidistant along the split.

FIRING

Process of exposing a clay body to intense heat, initially to bake the clay and then to melt the applied GLAZE so that it vitrifies and adheres to the ceramic surface. Several firings may be needed to complete the manufacture of a piece.

The preliminary or BISCUIT firing transforms the clay, physically and chemically, into a hard and permanent object. Different types of clay require different degrees of heat for successful biscuit firing: 700 to 1200 degrees Centigrade for EARTHENWARE, 1200 to 1350 degrees for STONEWARE, and 1250 to 1450 degrees for PORCELAIN.

A subsequent glost firing fuses the glaze and any metal oxide pigments to the biscuit piece. A more varied palette is achieved by painting metal oxide pigments, called overglaze or enamel colors, over the glaze after the glost firing. These are then fired at a lower temperature, just high enough to soften the glaze to which the colors become affixed.

Lusterware must undergo a third firing in a muffle KILN that

protects the sensitive decorated surface from ash and direct heat. The objects are decorated with a thin film of metallic oxides and then fired in a reduction atmosphere, rich in carbon monoxide, that is attained by burning smoky fuel or by reducing the intake of oxygen into the kiln. This oxygen-poor environment causes the metallic oxides to adhere to the surface of the piece; when burnished, they produce an iridescent decoration. This technique was developed in the eighth century in what is now Iran and spread by way of North Africa to Spain in the fourteenth and fifteenth centuries and to Italy in the sixteenth century. It ultimately moved northward, becoming especially popular in England in the nineteenth century.

Lower-temperature firings—generally between 700 and 900 degrees Centigrade—to affix enamels and produce LUSTER on already-glost-fired wares occur in a muffle kiln (French, *petit feu*; Italian, *piccolo fuoco*). The higher-temperature glost firings required for underglaze porcelain and for in-glaze earthenware decoration take place in a higher-temperature kiln at temperatures normally between 1200 and 1400 degrees Centigrade (French, *grand feu*; Italian, *grande fuoco*). See also METALLIC OXIDES.

FLASHING

Fusion and coloration that result at high temperatures, either when flames come in direct contact with the piece or material

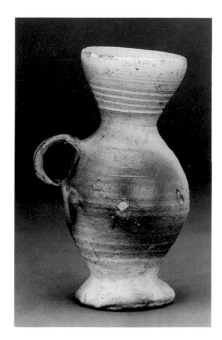

FLASHING
Drinking Jug. German (Siegburg), 15th century. Stoneware, H: 15.1 cm (6 in.); W (incl. handle): 9.3 cm (3¹¹⁄₁₆ in.). BM, MLA 1855, 7-25, 4.

settles on it during FIRING. In a KILN fired with wood, for example, fine ash can fall onto the high-fired piece and unexpectedly produce areas of flashing with a scorched appearance. Salt glazing, by which common salt is thrown into the kiln during the firing of STONEWARE to produce a thin, glass-like, often matte appearance, is a form of deliberate flashing. See also GLAZE.

FLUX

Base oxide that lowers the melting point of such vitrifiable materials as STONEWARE, PORCELAIN, glass, enamel COLORS, and GLAZES. By combining with the SILICA present in these materials, fluxes promote the creation of a glass at a lower temperature than would otherwise occur without the alkaline material.

Fluxes are commonly added to overglaze pigments to lower the required temperature, so that the enamels fuse to the softened but unmelted glaze onto which they are painted. Common fluxes include sea salt, white and red lead, FELDSPAR, borax, soda, and various organic ashes, such as those of ferns, bone, wine sediment, and seaweed.

FOOTRING

See PLATE.

FRIT

GLAZE ingredient that renders insoluble or helps control a soluble or volatile substance to which it is added; it can also function as a FLUX in clay bodies and SLIPS. A frit is normally composed of SILICA (found in sand or quartz), a flux (such as potash or soda), and, occasionally, pigment. Before use, the mixture must first be calcined and pulverized.

Ceramic frits have various applications. In the early twentieth century, for example, it was discovered that a frit added to many lead glazes transforms the toxic lead into an insoluble and safe lead silicate. Some fluxes are fritted so that they do not dissolve in water. Because they have a predictable and uniform melting rate, frits can help combine glaze materials and control their fusion. Certain ceramic bodies—such as those of soft-paste PORCELAIN and IZNIK ware—include high proportions of frit to make them glass-like, i.e., hard and translucent.

GARNITURE DE CHEMINÉE
(FRENCH, "CHIMNEY
DECORATION")

Group of PORCELAIN vases decorated as a set to embellish a mantelpiece. The vases usually number three, five, or seven, of alternating baluster and beaker shapes.

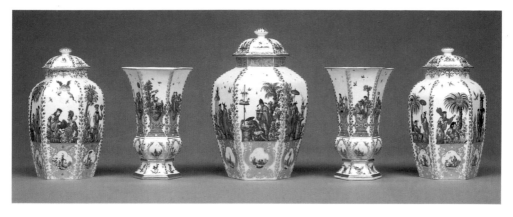

GARNITURE DE CHEMINÉE

Set of Five Vases. German (Meissen; painting attributed to Johann Gregor Höroldt [1696–1775]);
largest vase molded by Schiefer, c. 1730. Hard-paste porcelain. Lidded vase, H: 37.3 cm (4¹¹⁄₁₆ in.);
W: 24.1 cm (9½ in.); Lidded vases, H: 32.2 cm (12¹¹⁄₁₆ in.); W: 19.4 cm (7⅝ in.);
Open vases, H: 27.6 cm (10⅞ in.); W: 17.8 cm (7 in.). JPGM, 83.DE.334.1-.5.

GILDING

The application of gold to the surface of an object for decorative purposes. Before the nineteenth century, four methods were most commonly used in applying gold to ceramics. Gold leaf could simply be applied to the surface with a sticky semiliquid called *gold-sizing*. Another technique used pulverized gold mixed with lacquer, which was painted onto the surface. The latter technique was slightly more permanent, though neither process involved FIRING the gilding, which was easily worn off.

During the eighteenth century, SÈVRES employed two different techniques of gilding, depending on what kind of paste was used. For soft paste, a gold powder obtained by crushing gold leaf was either painted or powdered onto the surface; the gold leaf was then made to adhere to the surface through the use of a mordant obtained by the evaporation or condensation of a mixture of garlic and vinegar. It was generally applied up to three times to produce the desired thickness. It was fired at a low temperature and then polished with a smooth, hard stone, such as agate or hematite, and could be tooled with decorative motifs.

After the 1770s, hard- as well as soft-paste PORCELAIN could be gilded with the "MEISSEN gold" technique, obtained by reducing gold into chloride of gold, which was then precipitated with iron sulfate. This substance was further transformed into gold powder, which was painted onto the ceramic surface with a size of turpentine oil and then fired at a low temperature. It too was polished with a hard stone and then could also be tooled.

The nineteenth century saw a fundamental change in the way gilding was applied to porcelain. Transfer gilding was to become

the norm at Sèvres. The designs were first printed with gold powder and were then dusted in order to give the results greater thickness and richness. See also TRANSFER PRINTING.

GILDING
Ice-Cream Cooler. French (Sèvres), 1811. Hard-paste porcelain, H: 34.2 cm (13½ in.); max. W: 28.9 cm (11⅜ in.). BM, MLA 1985, 12-3, 2.

GILDING
Cup and Saucer. French (Paris; Dihl and Guerhard), c. 1815–20. Hard-paste porcelain, H: 6.8 cm (2¹¹⁄₁₆ in.); Diam (saucer): 13.2 cm (5³⁄₁₆ in.). BM, MLA 1936, 7-15, 135.

GLAZE

Glassy coating fused to a ceramic body either to seal it against moisture, as is necessary in the case of porous EARTHENWARE, or to decorate it with a variety of colors and textures. Glazes are composed of glassmaking elements, stabilizers, and FLUXES that are calcined to produce a homogenous and insoluble powder. This powder is dusted or sprayed onto the ceramic piece. It can also be suspended in water which can be poured over the object or as a bath into which the object is dipped; the water is immediately absorbed into the clay body, leaving a powdery film on the surface. A so-called glost FIRING at temperatures slightly below those of the initial BISCUIT firing melts the powder onto the piece.

Lead glazes include a lead oxide that serves as the primary flux and imparts a clear brilliancy to the glaze. Used since the second century A.D., lead glazes can be pigmented with a variety of METALLIC OXIDES. They can also serve as a simple transparent coating over biscuit-fired ware or over painted decoration to protect and render glossy the underlying surface. This type of clear "varnish" lead glaze is called a *kwaart* (Dutch) or a *coperta* (Italian). The medieval clear lead glaze, made of *galena* (lead sulfide), was occasionally mixed with iron oxide or manganese oxide to color it brown or black. This lead sulfide glaze, however, was soon superseded by other recipes because of troublesome impurities as well as the danger of its soluble and toxic lead oxide. In Renaissance Italy, the *coperta* was commonly made from a MARZACOTTO FRIT.

Tin glazes, normally fired on earthenware, were used by the

GLAZE

Cipriano Piccolpasso (Italian, 1524–1579). *Method of Glazing* from *Li tre libri dell'arte del vasaio* (1557), fol. 55r.

This illustration shows the manner in which ceramists should delicately hold their MAIOLICA wares when dipping them in white glaze.

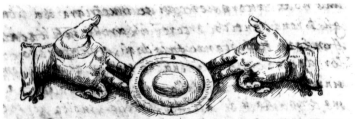

Assyrians three thousand years ago and by Persian and Egyptian
potters from the eighth to the eleventh century, at which time
these glazes were introduced from North Africa into Spain. From
the important potteries of Málaga in the south and Paterna and
Manises in the north, Spanish tin-glazed earthenware, or
HISPANO-MORESQUE ware, was exported to Italy, where it sparked
the development of Renaissance MAIOLICA. Since their tin oxide
particles reflect light, fired tin glazes have the great advantage
over lead glazes of producing an opaque white ground against
which painted decoration appears brilliant. Tin glazes are also less
easily fused than lead glazes and, therefore, are less apt to run or
blur in the KILN.

Salt-glazed STONEWARE first appeared in the late Middle Ages
in such Rhenish centers as Cologne, Raeren, and Siegburg,
becoming popular in England between the seventeenth and nine-
teenth centuries. Salt-glazed surfaces are produced by throwing
common salt into the kiln when the firing reaches its greatest tem-

perature, usually around 1000 degrees Centigrade. Elements of the salt combine with silicates in the clay body to form a thin, slightly pitted glaze surface. Unpigmented, the colors depend entirely on the clay and normally range from white to gray. Salt-glazed wares are occasionally covered with an iron oxide wash to produce a brown body, or else they are pigmented with metallic oxides, commonly cobalt or manganese. (See also *scratch blue* and *scratch brown* under STONEWARE.)

Feldspathic glazes that include powdered FELDSPAR were usually used on objects of hard-paste PORCELAIN. Since these glazes require only one high-temperature firing to melt into natural glass and become incorporated with the vitrified porcelain body, they provide a remarkably hard, thin, and brilliant glaze coating.

Smear glazes produce very thin, slightly glossy surfaces on such wares as biscuit porcelain or dry-bodied stonewares, including basalt or caneware. These glazes are not painted on the wares; they are placed in the kiln separately (in a crucible, for instance, or wiped on the inside of the SAGGAR). The soft glaze becomes volatile at high temperatures, depositing a thin trace of glaze on the fired object.

GLOST	See FIRING.
GREENWARE	Formed ware, such as that in the LEATHER-HARD state, that is not yet dry enough for FIRING.
GROG	Pulverized ceramic material or bits of quartz or sand added to wet CLAY to provide texture, give body to facilitate handling, aid in uniform drying, reduce shrinkage, and counteract warping during FIRING.
GROUND COLOR	Background color used to cover the surface of a ceramic, with decoration painted either directly onto the color or in RESERVES left white for this purpose. It first appeared on Persian and Syrian EARTHENWARE during the Middle Ages. By the sixteenth century, the technique was used in Faenza and in Venice, and later in the seventeenth and eighteenth centuries in Liguria, on earthenware covered with a blue ground on which the decoration was painted. This technique was imitated by ceramists in Holland and in France at Nevers, and the style ultimately spread to many of the other European ceramic centers. During the eighteenth century, ground colors were often used to decorate PORCELAIN. For instance, many of the wares produced by both MEISSEN and

41

SÈVRES have ground colors with areas left white for painted scenes or other decorations; they were probably inspired by Chinese prototypes. The range of colors used was limited only by the ceramist's imagination and technical ability; some of the more popular are deep blue, pink, yellow, apple green, turquoise, violet, purple, and red.

GROUND COLOR
Vase (one of a pair).
French (Sèvres), 1768–69.
Soft-paste porcelain,
H: 45.1 cm (17¾ in.).
JPGM, 86.DE.520.

Several factories in England, such as Worcester and Chelsea, also used ground colors on their wares, in direct competition with the work being produced on the Continent. Josiah WEDGWOOD's use of light blue, lilac, pink, and sage green on his unglazed wares accorded with late-eighteenth-century taste. His wares were then often decorated with relief designs in white.

GROUND COLOR
Lidded Potpourri Vase (Vaisseau à Mat). French (Sèvres), c. 1760.
Soft-paste porcelain, H: 37.5 cm (14¾ in.). JPGM, 75.DE.11.

***HAFNER* WARE**
(GERMAN, "POTTER," "STOVE BUILDER")

Nineteenth-century term, now outmoded, referring to a type of relief-molded and lead-glazed EARTHENWARE, usually stove tiles but also vessels, produced in Germany, Switzerland, and Austria from the mid-fourteenth century. Originally glazed entirely in green, by 1500 the glaze palette had expanded to include yellow, ocher, blue, and brown. Since these GLAZES were lead-based, the colors often dripped and ran together when FIRED. By 1550, Silesian potters employed tin glazes, often separating the areas of color with deep incisions in the clay to prevent the colors from intermingling.

HARDENING ON

When underglaze colors are used on BISCUIT, a special firing at a low temperature (600 to 800 degrees Centigrade) is necessary to burn off any oil or organic materials in the colors. This technique is often necessary when TRANSFER PRINTING has been used and prevents CRAWLING and BLISTERING.

HARD-PASTE PORCELAIN See PORCELAIN.

HAUSMALER
(GERMAN, "AT-HOME
PAINTER")

An independent artist working from his or her own studio. Most *Hausmaler*s decorated ceramics but some worked on glass. As the name implies, the best-known of these artists were from Germany, where this system flourished during the late seventeenth and eighteenth centuries, though such independent decorators or *chambrelans* (as they were known in France) also worked in Austria, England, and France. At the height of their popularity, the *Hausmaler*s were some of the most accomplished artists painting on ceramic or glass. They either purchased undecorated ceramics from local factories or used oriental wares, often of the blue-and-white variety, which they painted with enamel colors, occasionally highlighting the pieces with GILDING. See also CLOBBERED WARE.

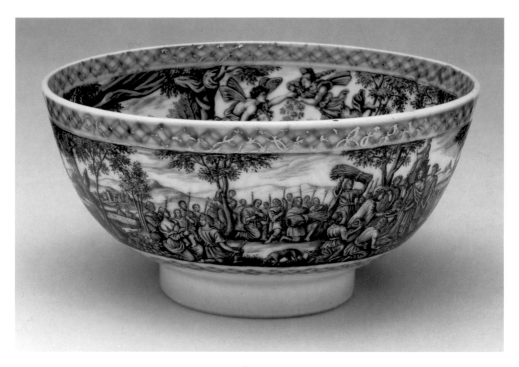

HAUSMALER
Bowl. Chinese (Kangxi), c. 1700. Hard-paste porcelain. Painted decoration: Ignaz Preissler (born 1676); German (Breslau), c. 1715–20. H: 7.3 cm (2⅞ in.); Diam: 14.9 cm (5⅞ in.). JPGM, 86.DE.738.

HISPANO-MORESQUE Tin-glazed EARTHENWARE, especially lustered dishes, vases, tiles,
and DRUG JARS, produced in Spain from the twelfth to the eigh-
teenth century. Moorish centers in the south of Spain—such as
Almería, Málaga, and Murcia—predominated until the overthrow
of Moorish rule in the fifteenth century, when potters began to
move north to the more stable and prosperous Valencian region
in the northeast.

The LUSTER technique, first mastered by Persian potters who
had been using it since the eighth century, arrived in Spain by way
of North Africa. Many of the painted patterns derive from
Islamic sources and are often coupled with European motifs, such
as heraldic animals and coats of arms.

IMPASTO

Thick pigment—such as overglaze enamels, colored SLIPS, and some underglaze colors—that stands out slightly in relief from the ceramic surface when FIRED. Impasto decorations include the thick cobalt blue designs, called *zaffera in rilievo* (Italian, "relief blue"), found on a type of Florentine MAIOLICA of the mid-fifteenth century, as well as the tomato-red BOLE embellishment on IZNIK ware of the late sixteenth century.

IMPASTO

Two-Handled Pharmacy Jar (Orciuolo Biansato). Italian (Florence), c. 1420–40. Tin-glazed earthenware, H: 31.1 cm (12¼ in.); max. W: 29.8 cm (11¾ in.). JPGM, 85.DE.56.

The blue impasto decoration on this jar was painted on so thickly (around the neck and base, for instance) that it began to drip down the sides of the jar during FIRING.

IRONSTONE

See STONEWARE.

IZNIK WARE

Type of ceramic ware from Iznik, Turkey (southeast of Istanbul), dating from the end of the fifteenth through the seventeenth century. Iznik potters mainly produced tiles, dishes, ewers, lamps, and straight-sided tankards of a white, vitreous clay body (often called a *frit paste*) covered with a white SLIP. The early decoration of foliate and floral arabesques in dark and light blue under a

IZNIK WARE
Bottle Decorated with Underglaze Roses and Other Flowers. Ottoman Turkish (Iznik), c. 1560–80. Earthenware, H: 34.8 cm (13¹¹⁄₁₆ in.). BM, 1878, 12-30, 465.

glossy clear glaze was inspired by Chinese patterns (called *hatayi*), such as those of Ming dynasty porcelain (1368–1644), and by scrolling floral motifs (called *rumi*) associated with Ottoman ornament.

By the early sixteenth century, particularly under Süleyman the Magnificent (reigned 1520–66), Iznik pottery was flourishing. The palette expanded to include turquoise, green, purple, and black, and the decorative repertory also expanded to comprise such motifs as stylized flowers (especially carnations and tulips), bunches of grapes, three-masted ships, and, less often, figure scenes. By the second half of the sixteenth century, BOLE was commonly used for its dense and brilliant tomato-red decoration.

By the seventeenth century, Iznik wares were exported to Italy, where they inspired the production of so-called *candiana* MAIOLICA in Padua between 1620 and 1640.

JASPERWARE See WEDGWOOD.

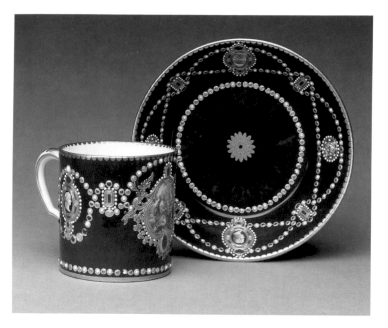

JEWELED DECORATION
(JEWELING, JEWELING
ENAMELING)

A rare form of decoration perfected and popularized at SÈVRES
during the 1770s and 1780s. Engraved steel dies are used to pro-
duce individual foils in gold leaf. Small drops of translucent
enamel are then applied to these gold-leaf foils, which are fired at
a low temperature so that the enamel and foil fuse. They are then
applied to the surface of the PORCELAIN and refired, again at a
low temperature. The workers Parpette and Coteau were the most
famous jewelers at Sèvres during the height of the fashion for
jeweling in the 1780s. Jeweled decoration was used on vases, cups
and saucers, and other types of wares; its extreme fragility indi-
cates that these wares were ornamental rather than for use. Sèvres
jeweled production was often faked during the nineteenth cen-
tury. The technique was later used in England, primarily by
Worcester, Spode, and Copeland.

JIGGER AND JOLLY

This machine was first used during the nineteenth century in the
mechanized production of plates. A BAT of clay is flattened with a
spreader on a revolving turntable and is then placed on a shaped
MOLD. A *profile* presses the clay onto the mold, at the same time
removing excess clay and cutting the outside and the footring of
the plate. The revolving mold itself forms the inside of the plate.
When making cups, the machine is called a *jolly* and is also used
with a profile. The clay is pressed into the mold, which forms the

outside of the cup. At the same time, the profile creates the hollow of the cup by cutting away the excess clay on the inside.

KAKIEMON Style of decoration derived from the work of the Kakiemon family of Japanese potters. Kakiemon Sakaida (1596–1666), working at Arita, is credited with having been the first potter to introduce enamel decoration to Japanese ware, using such colors as red, blue, green, yellow, and black. He and his descendants produced fine translucent white PORCELAIN elegantly and sparsely decorated with figures in landscapes and with birds (herons and quails), squirrels in a hedge, flowers, bamboo, and such symbolic animals as tigers and dragons and the phoenix. The wares are usually small bowls and vases of square, octagonal, or hexagonal section. During the seventeenth and eighteenth centuries, these wares were imported into Europe, where they were highly prized and widely imitated. The most important European centers producing wares inspired by the original Japanese products were MEISSEN, Chantilly, Chelsea, Bow, and Worcester.

Kakiemon Sakaida's descendants, considered National Living Treasures in Japan, continue to work at Arita in Hizen Province.

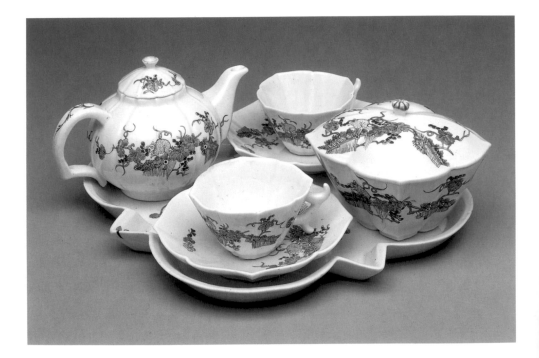

KAKIEMON
Tea Service. French (Chantilly), c. 1730–35. Soft-paste porcelain, H (teapot): 8.9 cm (3⅓ in.);
W (tray): 22.4 cm (8¹³⁄₁₆ in.). JPGM, 82.DE.167.

Kaolin

Primary clay of aluminum silicate that is an essential ingredient of true, or hard-paste, PORCELAIN since it fires to a white and hard state. Also called China clay, kaolin is said to have been discovered in the Gaoling (or "high ridge") mountains in China. Not surprisingly, kaolin deposits are frequently found close to important porcelain factories, such as the one near Limoges, France.

Kiln

Oven used to fire ceramic ware; its name derives from the Latin word for kitchen, *culina*. Early on, pottery was simply fired in trenches covered with sherds and brushwood. Later, kilns of various forms and types of air circulation (such as up-draft, cross-draft, or down-draft) were developed to improve on this method by walling in the fire to conserve heat. These early kilns were

Kiln

Cipriano Piccolpasso (Italian, 1524–1579). *Kiln* from *Li tre libri dell'arte del vasaio* (1557), fol. 35r.

Workmen stoke a kiln that has been mortared shut for FIRING.

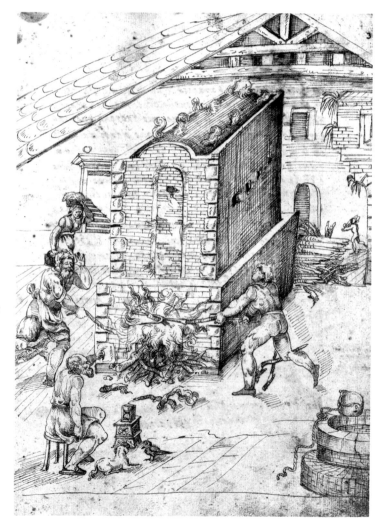

sealed shut and then broken open after each firing, lasting only a few firings before they required rebuilding. Subsequent innovations included reinforced construction to increase kiln longevity and the use of oil, gas, or electricity to improve fuel efficiency.

Modern heating methods also made possible the development of *tunnel kilns*—used for continuous and systematized production—in which a fire is kept constantly burning in a long chamber through which the wares pass on moving carts.

Used for firing delicate ware such as lustered or enameled pieces, *muffle kilns* include a permanent inner chamber that protects the ware from direct flame and gases.

Although unglazed wares can simply be stacked on one another in the kiln, glazed pieces must be kept separate so that the melting glazes will not fuse them together. For this purpose, *kiln furniture* is required for GLOST firing. Made of REFRACTORY material such as fire-clay that is able to withstand high temperatures without melting, these variously named movable kiln fittings include pegs and footed supports used to separate glazed objects from one another or raise them off the shelves, such as *stilts*, *spurs* (or *cockspurs*), *saddles*, *pips*, *firing rings*, and *trivets*; slabs used as kiln shelves, called *tiles*, *rafters*, or *bats*; and the vertical supports for these tiles, known as *girders*, *sluggs*, *props*, *pillars*, or *castles*.

LEATHER HARD

Leather-like condition of a ceramic body after some of the moisture has evaporated from the clay. Leather-hard wares are ready to be trimmed or decorated with SLIP but are not yet dry enough for BISCUIT FIRING.

LUSTER

Technique of applying an iridescent decoration to ceramics by depositing a metallic film onto GLAZES. Oxides or sulfides (salts) of such metals as silver, copper, or gold are dissolved in acid, combined with an oily medium, and painted onto the wares. These "paste" lusters, subsequently fired in a reduction atmosphere, cause a metallic film to adhere to the ceramic surface that, when burnished, becomes iridescent.

First developed in the Middle East in the eighth century, the technique was known throughout the Islamic world, appearing on Persian, Egyptian, Syrian, and HISPANO-MORESQUE earthenware before it spread to Italy, where the technique was mastered at the centers of Gubbio and Deruta in the early sixteenth century.

Although luster decoration continued to be popular on Spanish wares through the eighteenth century, by 1600 it had been replaced in the rest of Europe by the more fashionable ceramic

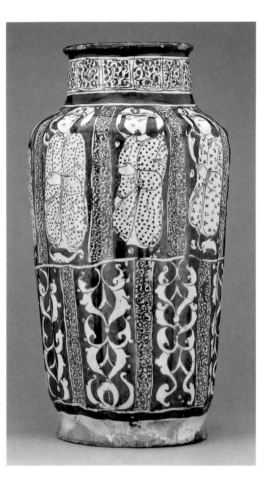

LUSTER

*Jar Painted in Luster with
Panels Containing Figures
and Arabesques.* Iranian
(Kashan), late 12th
century. Fritware,
H: 30.5 cm (12 in.); Diam
(at base): 12.8 cm (5 1/16 in.).
BM, OA G.1983.234.

LUSTER

Pitcher. English
(Wedgwood), c. 1815.
Earthenware with luster
glaze, H: 13.3 cm (5 1/4 in.);
W (incl. handle): 16.6 cm
(6 1/2 in.). BM, MLA 1970,
1-4, 52.

LUSTER

Wall Plaque. English (Sunderland; Moore and Co.), c. 1840–60. Earthenware, central scene printed in black and filled in by hand, edges lustered in pink and brown; 22.6 × 20.1 cm (8⅞ × 7¹⁵⁄₁₆ in.). BM, MLA 1927, 4-21, 1.

GILDING and SILVERING. Toward the end of the nineteenth century, however, workshops such as those of William De Morgan (1839–1917) and Minton, Ltd. in England, and Ulisse Cantagalli (d. 1902) in Italy, revived and elaborated the techniques of Islamic and Renaissance luster decoration. By this time, some studios had begun to employ the simpler technique of liquid luster, by which precious metals such as gold and platinum in liquid form are fused to the ware at low temperatures in an oxidizing KILN atmosphere.

LUSTERWARE

See FIRING.

LUTING

The process of joining slabs of clay or the various parts of an object, such as feet, spout, or handles. FETTLING eliminates the unsightly seam marks or other join marks produced by this technique. See also SPRIGGING.

MAGOT

Term used to describe a grinning, seated Chinese figure, made in various versions and of various materials, especially PORCELAIN. The figures derive from representations of the monk Pu-tai Ho-shang, but they can also can depict anonymous Chinese men and women. By the early eighteenth century, the form was popular on porcelain from such factories as Chantilly and MEISSEN. By the mid-eighteenth century, the famous Parisian merchant Lazare Duvaux was employing this term, as well as *pagode*, to describe the figures he was selling to his elite clientele.

MAIOLICA	Italian tin-glazed EARTHENWARE dating from the Renaissance. The name derives either from *Majorca*, the island that served as an entrepôt for many of the HISPANO-MORESQUE ceramics imported into Italy in the fifteenth century, or else from the Spanish term *obra de Málaga* for the imported "Malagan wares."

Throughout the Renaissance, the term *maiolica* referred solely to lusterware, including imported Spanish as well as Italian products; eventually it came to signify all Italian earthenware, lustered or not, covered with a tin GLAZE. The technique of covering earthenware with a tin glaze—producing an opaque white ground to set off the brilliance of the painted decoration—is similar to that used for delftware and faïence.

The main maiolica potteries of the Renaissance were located in Bologna, Cafaggiolo, Castel Durante, Castelli, Deruta, Faenza, Ferrara, Florence, Gubbio, Montelupo, Naples, Pesaro, Siena, Urbino, and Venice. In the seventeenth and eighteenth centuries, maiolica passed from vogue as PORCELAIN and creamware became more popular. Its production continued to flourish, however, in the towns of Albisola, Genoa, and Savona in Liguria, and Castelli in the Abruzzi region.

MAJOLICA

Anglicized version of the Italian *maiolica*, referring to tin-glazed and some lead-glazed EARTHENWARE of the nineteenth century.

MARKS

Marks on ceramics that are generally either painted, stenciled, impressed, incised, molded, or printed and are used for many different reasons. Most often they indicate the country of origin or name of the company that produced the piece. They also help to

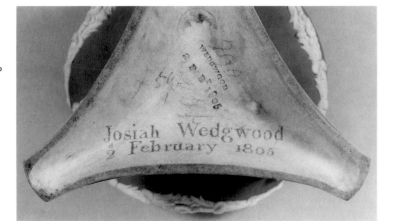

MARKS: PAINTED AND IMPRESSED
Maker's mark painted and impressed on the underside of a pastille burner. English (Wedgwood), dated 1805. Stoneware (jasperware). BM, MLA 1909, 12-1, 28.

identify or highlight some aspect in the production of the
ceramic, such as the name of the ceramist, designer, painter, mod-
eler, repairer, or any other craftsman who worked on or pro-
duced the ware. An object can often be dated by its marks, either
because a system of symbols or letters was adopted by a particular
company to indicate specific years or because certain marks were
in use only at certain times. Marks can also indicate the composi-
tion of the paste, the original owner's name, or the reason for
which the piece was made, such as for a World's Fair.

In Europe, marks appear to have been used on ceramic pieces
in Italy as early as the mid-fifteenth century. Their widespread use
began in the eighteenth century. By the end of the nineteenth
century they were in common use all over the world; they are usu-
ally required by law to this day.

MARZACOTTO

(ITALIAN, FROM THE FRENCH
MASSICOT, "LEAD OXIDE")

Silicate of potash FRIT developed in Renaissance Italy for making
GLAZES. Prepared by calcining together wine sediment and sand,
the *marzacotto* served as the basis for both clear and pigmented
MAIOLICA glazes.

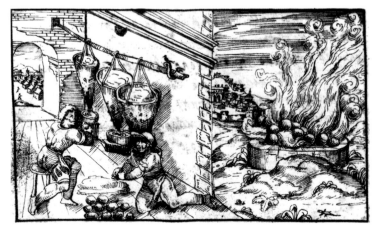

MARZACOTTO
Cipriano Piccolpasso
(Italian, 1524–1579).
*Straining and Burning the
Lees for the Marzacotto* from
Li tre libri dell'arte del vasaio
(1557), fol. 22v.

To prepare the *marzacotto*,
workmen form balls of
wine sediment that they
then strain in conical sieves
and burn in a pit.

In about 1706–8, Johann Friedrich Böttger (1682–1719), working as an alchemist for Augustus the Strong, Elector of Saxony and King of Poland, was experimenting with heat-resistant crucibles for making gold. In association with Ehrenfried Walther von Tschirnhaus (1651–1708), he produced an extremely hard, dense red STONEWARE, the body of which closely resembled natural hard stone. Though certainly not the first red stoneware produced in Europe, Böttger's wares were much harder and denser than those produced in either England or Holland, and they could be polished and engraved on the lapidary wheel.

Böttger continued his experiments and was able to produce the first European hard-paste white PORCELAIN, with clay from Colditz in Saxony. Because of this discovery, in 1710 Augustus the Strong established his porcelain factory in the Albrechtsburg Fortress at Meissen, where it remained until 1865. Many of the early pieces were inspired by Chinese and Japanese examples from the personal collection of Augustus the Strong.

After Böttger's death, the factory management was taken over by Johann Gregor Höroldt (1695–1775), who guided it for the next twenty-five years, developing new colors and forms of decoration. Johann Gottlob Kirchner (born 1706), who was first hired in 1727, collaborated with Johann Joachim Kändler (1706–1775), who joined the company in 1731, until the former was discharged in 1733. For the next twenty years, Kändler continued to design new forms and figures, for which the company became justifiably famous.

During the Seven Years' War (1756–63) the factory was under Prussian control, and though it continued to function, it did so with difficulty. Its preeminent position in Europe passed to SÈVRES, the French factory that was to dominate porcelain production and design during the second half of the eighteenth century. In 1774, Count Camillo Marcolini (1736–1814) was appointed director at Meissen, a position he filled until his death. Unfortunately, the company was never able to regain its European supremacy.

Meissen continued to produce porcelain during the nineteenth century and is still in operation today. The factory uses the MARK of a pair of crossed swords in underglaze blue. Meissen production and its mark have been widely imitated.

METALLIC OXIDES	Substances derived from metals that serve as ceramic FLUXES, colors, and opacifiers. Certain metal oxides also produce LUSTER on wares when FIRED in a reduction atmosphere.
MEZZA-MAIOLICA	See EARTHENWARE.
MING DYNASTY PORCELAIN	Hard-paste PORCELAIN produced in China during the dynastic period that extended from 1368 to 1644. In was during the Ming dynasty that porcelain manufacturing developed in China. Earlier pieces were usually decorated in underglaze blue, later pieces with colorful enamel designs. As more and more objects reached Europe during this period, Asian ceramics began to be used by the major European factories as models to be copied. Ming white porcelain decorated with underglaze blue was especially popular and influential in Europe.

MING DYNASTY PORCELAIN
Bowl. Chinese (Xuande), imperial factory, Jingdezhen; Ming dynasty, 1426–35.
Porcelain, H: 8 cm (3⅛ in.); Diam: 17.3 ccm (10¾ in.). BM, OA 1973.7-26.360.

MODEL　A three-dimensional object made or used as a prototype or pattern. It is often made of a less permanent substance—such as plaster, clay, or wax—than the ceramic itself. The model can be used to create a case MOLD from which a series of identical reproductions can eventually be made. Models are generally approximately one-sixth larger than the finished ware, due to the shrinkage sustained by the ceramic pastes during FIRING.

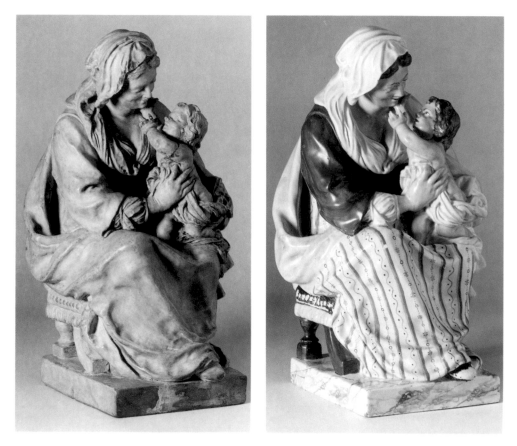

MODEL

Lucas Faydherbe (Flemish, 1617–1697). *Madonna and Child*, c. 1670. Terra-cotta, H: 38 cm (15 in.).
BM, MLA 1957, 11-1, 1.

Madonna and Child. English (Staffordshire; probably Enoch Wood [1759–1840]), c. 1790.
Pearlware, H: 30.7 cm (12 in.). BM, MLA 1954, 4-1, 1.

The terra-cotta model on the left was used to create a mold from which numerous copies
could be reproduced, such as the PEARLWARE example on the right.

Cavity, generally made of plaster of paris but sometimes of gypsum, clay, rubber, or metal, in which a fluid paste or other malleable substance is given a desired form.

There are several steps to making a mold. A hollow *case mold* is made from an original object, MODEL, or prototype, by casting plaster of paris around the original and then removing it after the plaster has set. The case mold is sometimes made in several pieces to help in its removal; sometimes it has to be cut away. A mold that cannot be removed by cutting and must be destroyed to remove the cast is called a *waste mold*.

After the case mold is reassembled, a plaster duplicate of the original, or *block mold*, is made by filling the hollow with liquid plaster of paris. This also can be done by carving a block mold out of wood or alabaster, thus producing a *block cutting*. The final or *working mold* is made by casting plaster of paris around the block mold and then removing it after the plaster has set. As many molds as required can thus be made from the case mold. It is in the working mold that the wares are actually formed before FIRING.

Slip-cast ware can be made by pouring SLIP into a plaster of paris or absorbent, biscuit-fired clay mold. Once the moisture has been partially absorbed and it has become CHEESE HARD, the mold can be removed.

A *press mold* or *pitcher mold* is used to make decorative elements—such as spouts, feet, or handles—that are attached to a ceramic body by SPRIGGING. The mold is usually made of lightly fired absorbent clay. The clay is pushed into the mold (called *pressing*) and can be removed once it shrinks slightly, becoming cheese hard. *Molding* is the process of pressing clay into molds to make the parts of an individual object, for instance, separate feet, a handle, or a spout. These are attached to the main body by a "repairer" (see LUTING). Molded decoration, that is, surface decoration, can also be made in this way and is either an integral part of the body of the piece or is attached by SPRIGGING. (See illustration on next page.)

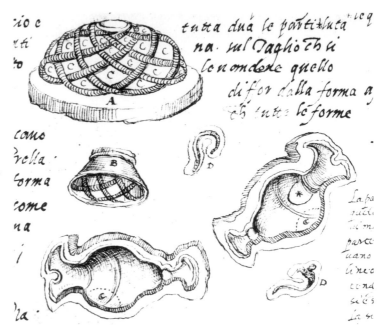

MOLD

Cipriano Piccolpasso (Italian, 1524–1579). *Molds and Forms* from *Li tre libri dell'arte del vasaio* (1557), fol. 18r.

Illustration of a convex (A) and a concave (B) plaster mold for making the body and foot of an openwork basket. Piece molds (C and D) serve to form a single-handled ewer.

MOLDED DECORATION

Molded Dish with an Allegory of Love (Crespina). Italian (Faenza), c. 1535. Tin-glazed earthenware, H: 7.3 cm (2⅞ in.); Diam: 28 cm (11 in.). JPGM, 84.DE.114.
The form of this piece was achieved by pressing clay into a mold much like the convex one (A) in the illustration above.

MOLDED DECORATION

Embellishment of the clay body formed when wet clay is pushed into a MOLD or when relief decoration is applied to the surface of the raw ware. An ancient technique, molded decoration appeared on Roman wares by at least 200 B.C. and on a wide variety of later wares, from Chinese pots of the Song dynasty (A.D. 960–1279) to nineteenth-century English STONEWARE. Molded Italian MAIOLICA forms—such as relief-ware plates like *crespine* (from the Italian *crespa*, "pleat" or "wrinkle") or *aborchiati* ("embossed"), strongly inspired by metalwork forms—became popular in the sixteenth century. By 1600, ever more Baroque shapes, including elaborate basins, vases, wine coolers, tureens, and cisterns, were being efficiently produced in plaster molds.

Cast-relief decoration—made from SLIP poured into a plaster mold, dried to a LEATHER-HARD state, and applied to the ware's surface—appears on such ceramics as German salt-glazed stonewares and WEDGWOOD stonewares, such as jasper, basalt, or caneware, whose fine grain could maintain the sharp outline of the decorative details. See also SPRIGGING.

MOLDED DECORATION

Vase. English (Fulham Pottery; John Dwight), c. 1685. Salt-glazed stoneware, H: 18.9 cm (7 7⁄16 in.); Diam: 11.7 cm (4 5⁄8 in.). BM, MLA Hobson (1903), F 14.

Clay was pressed into small concave molds to form the bird and running figure with parasol that embellish the body of this vase.

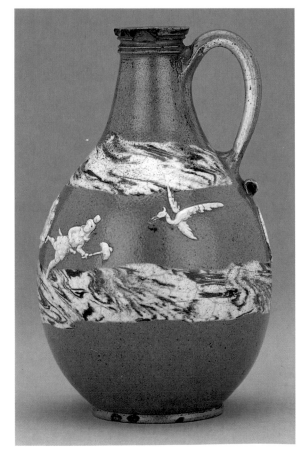

OPENING MATERIALS Substances including GROG, sand, and PITCHERS that can be added to clays. Opening materials can improve clays that would otherwise be too wet or plastic for handling, control clay shrinkage, and facilitate thorough drying of large pieces.

OXIDATION The presence of enough oxygen in the KILN for complete combustion of the fuel. In the GLOST firing, oxidation is important so that the desired colors of the METALLIC OXIDES fully develop. Oxidation can also tarnish silvered decoration on PORCELAIN.

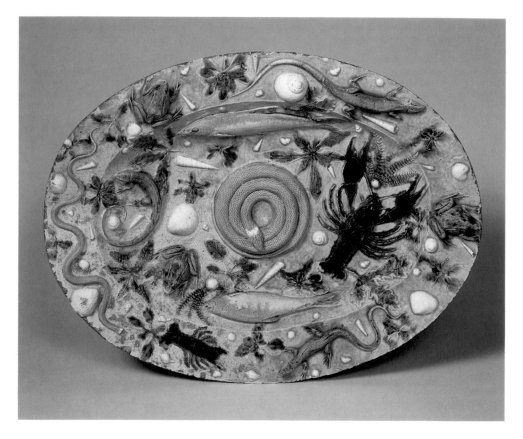

PALISSY WARE
Attributed to Bernard Palissy (French, 1510?–1590). *Oval Basin*, c. 1550. Lead-glazed earthenware, 48.2 × 36.8 cm (19 × 4½ in.). JPGM, 88.DE.63.

PALISSY WARE EARTHENWARE produced by Bernard Palissy (1510?–1590) at

(FIGULINES RUSTIQUES; Saintes and in Paris in the mid-sixteenth century, which naturalis-

"RUSTIC WARE") tically imitates a marsh or river environment. Geologist, surveyor, and scientist, Palissy cast from life various crustaceans, reptiles,

fish, and leaves in earthenware that he then attached onto tradi-
tional ceramic forms and colored with pigmented lead GLAZES.
These highly fusible glazes ran together during FIRING, increasing
the realism of the reproduced watery setting. Palissy's rustic wares
were so popular that they were imitated during his own lifetime
and then widely copied in the nineteenth century by such cera-
mists as Charles-Jean Avisseau (1795–1861) and his son Charles-
Joseph (1829–1908) of Tours and Joseph Landais (1800–1883),
also of Tours.

PARIAN WARE

See BISCUIT.

PARTURITION SET
(FRENCH, *SERVICE
D'ACCOUCHEMENT*; ITALIAN,
TAZZA DA IMPAGLIATA OR
VASO PUERPUERALE)

Group of MAIOLICA table vessels in which food was served to
women confined to bed after childbirth. The group consists of a
set of wares that fit together to form one baluster-like form. The
separate pieces commonly include a broth basin (*scudella*) covered
by an inverted plate (*tagliere*), a small bowl (*ongaresca*), a salt cellar
(*saliera*), and a pierced cover (*coperchio*). The painted decoration
frequently depicts birth scenes.

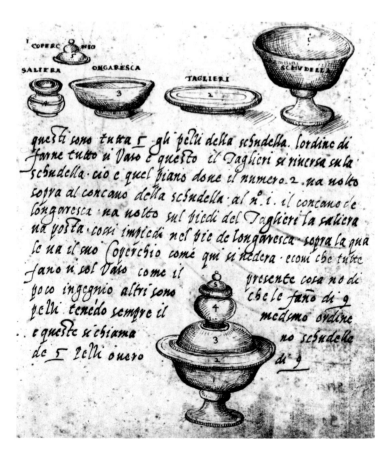

PARTURITION SET
Cipriano Piccolpasso
(Italian, 1524–1579).
Parturition Set from *Li tre
libri dell'arte del vasaio*
(1557), fol. 11r.

65

PASTE

Mixture of clays and other materials used to form the body of the ceramic. Different ingredients change the inherent qualities of the finished ware, generally producing either EARTHENWARE, STONE-WARE, or PORCELAIN (true or artificial).

PÂTE-SUR-PÂTE

(FRENCH, "PASTE ON PASTE")

Highly sophisticated technique in which translucent layers of white SLIP are painstakingly applied one by one to a darker ground, thus building up a design or pattern, usually in the Neo-classical or Empire style. Each layer of slip is allowed to dry completely before the next one is applied. The various layers of slip are carved before FIRING. In appearance, the designs bear some relationship to cameo carving and cameo glass and were inspired by a wide range of subjects from the Renaisssance through the nineteenth century.

Louis-Marc-Emmanuel Solon (1835–1913) was the most famous practitioner of this technique. After training at the SÈVRES manufactory, where the technique had originally been developed soon after 1851, Solon went to England in 1870 and worked for Minton, Ltd., where he set up a workshop and produced some of the most perfect examples of *pâte-sur-pâte*.

PÂTE-SUR-PÂTE
Louis-Marc-Emmanuel Solon (English, 1835–1913). *Plaque*. Minton Porcelain and Pottery Manufactory (Stoke-on-Trent, Staffordshire), c. 1880. Parian ware, H: 18 × 16.3 cm (7 1/16 × 6 7/16 in.). BM, 1920, 3-18, 26.

PEARLWARE See EARTHENWARE.

PETUNTSE A feldspathic mineral that, at a high temperature, becomes a natural glass. An essential ingredient in the making of hard-paste PORCELAIN, it is mixed with KAOLIN to give the finished product its hardness and translucency. The word derives from the Chinese *baidunzi* (or *pai-tun-tzŭ*, as it used to be transliterated), meaning "little white bricks." This was the shape in which the mineral was transported to the potters in China, where it was first used as a GLAZE component in the third century A.D.

PITCHER A container, usually with handle and spout, for holding and pouring liquids; also called a ewer or jug. In clay preparation, pitchers are bits of fired and crushed EARTHENWARE that serve as an OPENING MATERIAL.

PLATE The familiar shallow table vessel, although it can also function as an object for display. Most often circular or oval, a plate is usually composed of a depressed central medallion called a *well* (Italian, *cavetto*), or a *boss* or *loaf* if it is raised. Its sides, or *wall*, lead to the plate's *rim*, also called a *ledge* or *marli*, which is parallel to the well's bottom. The piece normally stands on a *footring* to raise it slightly from the underlying surface so that air can circulate beneath the piece, keeping condensation from occurring when hot food is placed on the vessel.

Types of MAIOLICA plates include various bowls called *tazze*, *ciotole*, or *scodelle* (also *scudelle*, *scodelli*); small bowls with wide rims called *tondini*; large, flat-based trenchers used for display or for serving food, called *taglieri*; various stemmed and footed bowls, called *ongaresche* or *alzate*; molded dishes with undulating surfaces, known as *crespine* or *aborchiati*; openwork plates or baskets, called *piatti traforati* or *canestrelle*; serving trays or *vassoi*; and display plates, known as *piatti da pompa* or *piatti da parata*. See also COPPA AMATORIA and PARTURITION SET.

PORCELAIN A usually white, vitreous, and translucent ceramic of which there are several types. The most common today is *hard-paste porcelain*, also known as *true porcelain* (French, *pâte dure*). Its most important ingredients are KAOLIN (white china clay) and a feldspathic stone called *chinastone* (or PETUNTSE); they are fired at a high temperature (1250 to 1350 degrees Centigrade, or even more), which

fuses the two ingredients into a glassy matrix. Hard-paste porcelain was first produced in China, where the essential ingredient, kaolin, was available. In Europe, kaolin only became available at the beginning of the eighteenth century; by 1709 it was being used by Johann Friedrich Böttger at MEISSEN to make true porcelain. Later in the century, potters in the town of Doccia in Italy produced a hard-paste porcelain that was grayer than most others known. It is called *masso bastardo*. In France, kaolin was only discovered in the 1760s and exploited by the manufacturers at Limoges and all the Paris porcelain factories. The body of an object is generally covered with a thin feldspathic GLAZE put on before the first FIRING. Decoration with enamel colors and gilding was painted on afterward and required subsequent firings.

Before kaolin was discovered in Europe, only *soft-paste porcelain* (artificial porcelain; French, *pâte tendre*) was made. The paste consists of a combination of white clays and ground glass that are vitrified while being fired at a lower temperature than hard paste (approximately 1200 degrees Centigrade). The paste is then ground up and combined with plastic clays to make it pliable. Glazes made of lead are then placed on the body and require another firing. Decoration in enamel colors painted on the surface requires a further firing to bond the surface embellishment to the piece.

The Medici factory in Florence was the first to produce this type of soft-paste ware in Europe, between about 1575 and 1587. Around 1700, porcelain began to be produced on a more commercial scale by the French factory of Saint-Cloud, followed by Chantilly in 1725 and Mennecy in 1735, among others. For the first thirty years, Vincennes/SÈVRES produced soft-paste porcelain exclusively. Unfortunately, soft-paste porcelain was subject to great losses in the KILN and was therefore not as economically viable as hard paste.

The term *bone china* was first used in 1836 for a true porcelain containing bone ash that had been marketed by Josiah Spode (1755–1827) as early as 1799. The ash of calcinated bone was added to the composition, making the resulting porcelain whiter and more translucent. It also helped reduce distortion during the firings, thus making the enterprise more economical. This is still the standard paste used in England.

POTASH

(POTASSIUM OXIDE)

Found in vegetable and wood ash, potash renders clay bodies denser, harder, and less malleable and increases the stability and color brilliance in GLAZES. Normally water soluble, potash must be FRITTED before use in ceramic preparations.

POTSHERD

Fragment of a fired pot, sometimes simply called a shard or sherd. When added to clay, certain crushed potshards can function as an OPENING MATERIAL to reduce shrinkage during drying and FIRING. Shards are often the subject of archaeological study, since they are frequently the only remains of discarded wares.

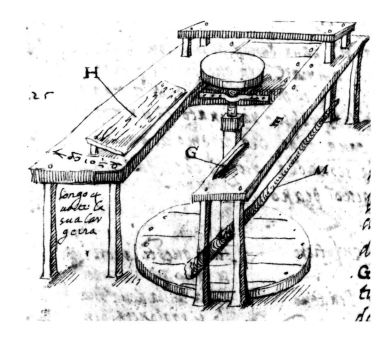

POTTER'S WHEEL
Cipriano Piccolpasso
(Italian, 1524–1579).
Potter's Wheel from *Li tre libri dell'arte del vasaio*
(1557), fol. 10r.

POTTER'S WHEEL

Flat disk (or "wheel head") that rotates on a vertical shaft used for forming vessels in clay. (See also THROWING.) The turning wheel supplies centrifugal force to a centered ball or BAT of clay, so that the potter, by applying hand pressure, can form a symmetrical, circular shape.

Known in ancient Egypt, China, and the Near East, early wheel types include the *slow wheel*, a turntable rotated by hand that was developed to aid in forming coiled pots (see COILING), and the *kick wheel*, which is powered by kicking (or rotating with a treadle) a flywheel added beneath the wheel head. Other early Chinese and Indian forms are driven by spinning the wheel head or a flywheel with a stick inserted into a notch on the rim of the disk. Today, wheels are usually powered by electric motors.

Wheels are also used to trim the thrown vessels when they have partially dried to a LEATHER-HARD state. Reattached to the wheel head, the piece is spun by the potter so that areas of unwanted clay can be uniformly shaved away using a trimming tool such as a blade, scraper, or wire loop.

POUNCED DESIGN

(ITALIAN, *SPOLVERO*)

Stencil used to transfer the outlines of an image or pattern onto a ceramic surface for painting. A paper drawing or print is pricked with small holes, through which a fine dark powder, called *pounce* (commonly gesso, charcoal, or gum sandarac), is dusted onto the ware. Ceramists often employed this method in the eighteenth century, although it may have been used as early as the sixteenth.

REDUCTION

KILN atmosphere starved of oxygen and rich, therefore, in carbon monoxide. Reduction can be produced by restricting the intake of oxygen into the kiln or by burning wet or resinous fuel. Muffle kilns are often used for reduction FIRING to help protect the delicate surface of some reduction-fired wares from exposure to flames or smoke.

A lack of oxygen during firing changes the resultant colors of metal oxides in GLAZES and clay bodies because it forces the oxides to release oxygen. Reduction is necessary to develop such high-firing glazes as copper-red, as well as to produce some LUSTERS.

REFRACTORY

Able to withstand very high temperatures without fusing. A type of refractory clay called fireclay is commonly used to construct KILNS and such kiln supplies as SAGGARS, kiln furniture, and muffle boxes. A type of refractory cement is also used to produce kiln furniture by casting. Both fireclay and refractory cement include high percentages of ALUMINA and SILICA.

REPAIRER

Worker who is responsible for joining all the separately cast or molded parts of an object or figure and preparing it for FIRING. See also SPRIGGING.

RESERVE DECORATION

Pattern that retains its original appearance while its surrounding area is differentiated from it by color or surface. It often appears as a design isolated within a painted border. Reserve decoration can be executed freehand or by using a resist technique. See also RESIST WARE.

RESIST WARE

Type of decoration in which the decorative patterns or designs on a vessel or other object are painted onto the surface with a substance such as hot molten wax, preventing the overall colored SLIP or LUSTER-pigment from affecting the waxed area. During FIRING,

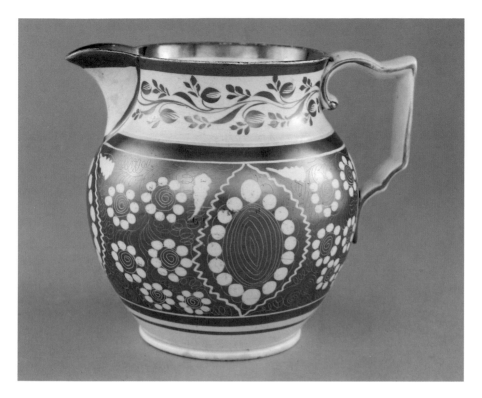

the wax burns away, revealing the design, which is generally the same color as the body of the piece, or white. Other resists commonly used are paper glued onto the surface, honey, glycerine, or varnish, all of which are either burnt off in the KILN during firing or are washed off after the overall slip or luster-pigment is in place.

ROSSO ANTICO
See WEDGWOOD.

SAGGAR
("SAGGER," "SEGGER")
Protective case made of REFRACTORY clay in which delicate or precious wares can be FIRED to shield them from smoke, ash, or gas in the KILN. Small pins can be inserted into the saggar wall to support and separate the pieces inside.

SAINT-PORCHAIRE WARE
See EARTHENWARE.

SCHWARZLOT

Decoration in black enamel, generally used in Germany during the second half of the seventeenth and the eighteenth century. HAUSMALERS used it extensively on glass and ceramics. The overglaze decoration is sometimes complemented by red with some GILDING. The decoration is often inspired by engravings of the period. The technique and the engravings were used extensively in the decoration of Asian export wares destined for the European market during the late eighteenth and the nineteenth century.

SCRATCH BLUE AND SCRATCH BROWN

See STONEWARE.

SÈVRES PORCELAIN MANUFACTORY

In 1738, two factory workers from Chantilly, Robert (1709–1759) and Gilles (1713-after 1752) Dubois, were asked by the government official Jean-Louis-Henri Orry de Fulvi to begin to experiment with the making of soft-paste PORCELAIN. These successful experiments took place in the Château de Vincennes to the east of Paris. By 1745, a private company was founded under royal protection to promote the making of porcelain. Part of the company's initial success was the result of its exclusive right to make the porcelain flowers that were in vogue at the time.

By 1752 the company was in financial trouble, and despite sub-

sidies from the king, it was unable to continue operations. The company was therefore dissolved and a new one created, one quarter of which was owned by the king. New and stringent restrictions were placed on all other porcelain factories in order to give the new royal establishment every advantage, though these restrictions were habitually ignored by the other companies producing porcelain.

In 1756 the factory was moved to Sèvres, west of Paris on the road to Versailles, where it remains to this day. Unfortunately it still experienced great financial difficulties, and by 1760 the king had assumed full ownership. With this royal patronage, the company was able to take advantage of the best artistic and technical talent available. It made great advances in the creation of new shapes and designs and developed such ground colors as dark blue (*bleu lapis* in 1752 and *bleu nouveau* in 1763), turquoise (*bleu céleste* in 1753), green, pink, and violet. It soon became the foremost porcelain manufactory in Europe. Louis XV and later Louis XVI, who inherited the factory, both took a personal interest in the company, overseeing its annual exhibition and sale at Versailles between Christmas and New Year's. Sèvres porcelain was also used extensively for official gifts to foreign dignitaries and monarchs, thus helping to spread its fame and influence.

Sèvres only produced soft-paste porcelain until 1768–69, when KAOLIN, one of the essential ingredients in the making of hard-paste porcelain, was discovered not far from Limoges, France. This important discovery would alter the history of the company. Hard-paste porcelain production became more and more important, and by 1804 the use of soft-paste porcelain was eliminated entirely.

The company was nationalized at the time of the French Revolution and only survived with difficulty. Napoleon, however, understood the importance of Sèvres in terms of world prestige and was an enthusiastic supporter of its products, following the once-royal tradition of giving porcelain as official gifts. Alexandre Brongniart (1770–1847) was appointed director in 1800, a post he held until his death. Under his direction, the company was kept at the forefront of porcelain production in Europe, with many new shapes and decorations designed by the most famous architects and artists. This tradition continued throughout the nineteenth and into the twentieth century. Today the factory is still owned by the French government and continues to produce a wide range of porcelain for state and private use.

The Sèvres factory has used many MARKS during its long history. As of 1753, interlaced L's, usually painted in blue, were combined with a letter of the alphabet to indicate the year of

manufacture. Many of the artisans who worked on individual wares would also affix their mark. In the 1770s and 1780s, hard-paste porcelain was generally distinguished by the red color of its mark and the addition of a crown above the interlaced *L*'s. The mark was changed at the time of the Revolution and has since changed with each succeeding political regime.

SGRAFFITO

(GRAFFITO, SGRAFFIATO, SGRAFFIO)

So-called *scratched* decoration that originated in China and spread through Persia to Europe, particularly the Italian centers of Bologna, Ferrara, and Padua, in the fifteenth and sixteenth centuries. English potters later employed this technique in the eighteenth and nineteenth centuries.

For *sgraffito* patterns, EARTHENWARE that has been dipped in a

SGRAFFITO

Dish with Representation of Marcus Curtius. Northern Italian (perhaps Venice), 16th century. Lead-glazed earthenware, Diam: 47 cm (18½ in.). BM, MLA 1889, 4-13, 1.

74

light-colored SLIP is incised to reveal the darker clay body beneath. The piece is then usually covered with a transparent lead GLAZE, under which METALLIC OXIDE pigments are sometimes applied. *Sgraffito* decoration can also refer to designs scratched through a glaze.

SILICA

(SILICON DIOXIDE)

A hard glassy substance that, together with ALUMINA and water, is an essential ingredient of clay. Silica is also an important component of ceramic GLAZES, melting to a transparent glass at high temperatures. Since it is a REFRACTORY substance, silica requires the addition of FLUXES. It is found in such natural materials as sand, flint, and quartz.

SILVERING

Oval Tray. English (Wedgwood), c. 1791–1800. Black basalt stoneware, L: 31.2 cm (12½ in.). BM, MLA 1909, 12-1, 123.

SILVERING

The application of silver to the surface of an object for decorative purposes. The process is similar to GILDING, though silvering was not as popular. It was used by some of the German factories, such as at MEISSEN or Bayreuth, and on red EARTHENWARE. It was also occasionally used at SÈVRES but was eventually replaced by platinum, which does not tarnish.

Potter's clay mixed with water to form a smooth, creamy liquid used to decorate ceramics, produce wares in slip-cast MOLDS, and attach separate unfired ceramic pieces together by SPRIGGING or LUTING. Colored slips, often yellow, red, or dark brown, have been used all over Europe to decorate pottery vessels. Some techniques used for these slip-decorated ceramics, or slipware, include *pâte-sur-pâte*; *dipping*, by which the ware is dipped into colored slip (see also SGRAFFITO); *trailing*, which produces patterns defined by slip poured in a thin stream on the vessel; and *combing* or *feathering*, which produces a wavy design when a toothed instrument or quill is pulled through lines of wet slip.

The French term for slip, *engobe*, refers to any coating used to decorate a ceramic piece or to conceal an inferior clay by covering it with a finer or whiter surface.

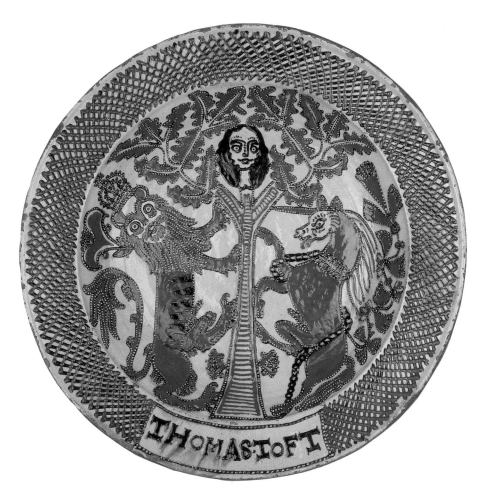

SLIPWARE: TRAILING
"Charles in the Oak" Dish. English (Staffordshire), signed *Thomas Toft*, c. 1650–75. Lead-glazed earthenware, Diam (approx.): 50.7 cm (20 in.). BM, MLA 1935, 7-16, 1.

SOFT-PASTE PORCELAIN See PORCELAIN.

SPONGING Decorative technique that establishes a mottled ground by applying one or more pigments or colored GLAZES with a sponge, such as appear on tortoiseshell ware. See also VARIEGATED WARE.

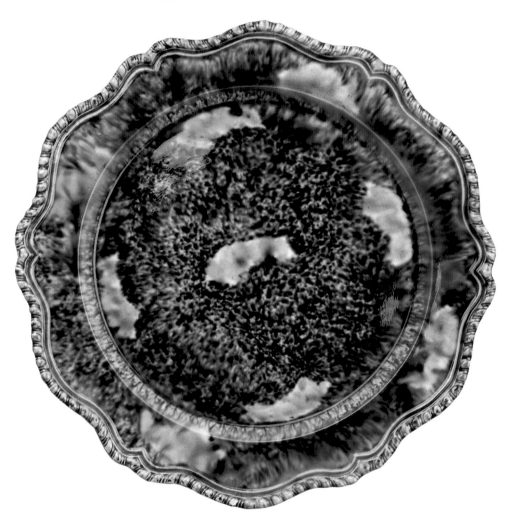

SPONGING
Plate. English (Staffordshire), attributed to Thomas Whieldon (1719–1795),
Fenton Vivian, Stoke-on-Trent, mid-18th century. Lead-glazed earthenware with colored glazes,
Diam: 39.8 cm (15¹¹⁄₁₆ in.). BM, MLA 1923, 1-22, 21.

SPRIGGING The process of attaching decoration to the surface of ceramic objects, before the first, or biscuit, FIRING. The decorative elements are made of clay and can either be freely modeled or made in a press MOLD (also called a pitcher mold). Usually SLIP, sometimes water, is used as a "cement" for the pieces. Josiah

WEDGWOOD was famous for using this technique, attaching differently colored decoration in contrast to the color of the body of the object, as in jasperware. See also LUTING.

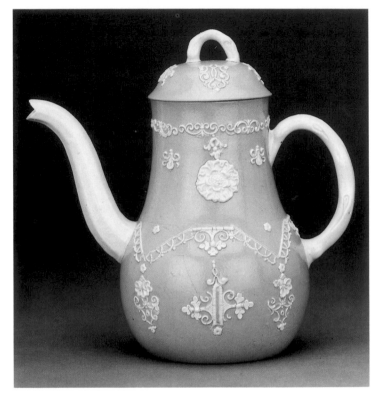

SPRIGGING

Coffeepot and Cover. English (Staffordshire), c. 1760. Salt-glazed stoneware, H: 17 cm (6¹¹/₁₆ in.); W (incl. spout and handle): 17.4 cm (6⅞ in.). BM, MLA Hobson (1903), G 59.

The spout, handles, and delicate molded ornaments around the body and cover of this coffeepot were attached by sprigging.

SPUR MARK

(STILT MARK)

Small flaw in the GLAZE caused by contact of the glazed piece with a spur or stilt during GLOST firing. On plates, spur marks are equidistant from a central point, either inside the footring, in the well, or around the rim, depending on the way the wares were stacked in the KILN.

STAMPING

The process of using a specially prepared tool to impress designs into the unfired clay of a ceramic object. It can be used to produce either an impressed or an intaglio design. Usually employed for decorative purposes, this technique is sometimes used for manufacturer's or maker's MARKS.

Stamping also refers to the use of a cutout relief to place painted decoration on unfired ceramics. The cutout is inked and repeatedly pressed against the ceramic body, thus leaving the inked impression on the surface. The object is then FIRED.

Dense and hard pottery, FIRING to an off-white or gray color. Stoneware must be fired at temperatures high enough to produce a partially vitrified and watertight body after a single firing. Stoneware can be twice-fired, however, to affix decorative GLAZES and pigments.

First produced in Europe in the Rhineland in the late Middle Ages, stoneware (often salt glazed) continued until the eighteenth century to be an important product of the Rhenish potteries at Cologne, Raeren, Siegburg, and in the Westerwald region. By the second half of the seventeenth century, stoneware was produced in England, particularly in Staffordshire, where it was often referred to as *Cologne ware*. Examples of stoneware types include:

Böttger red, an unglazed, porcellaneous ware developed by the alchemist Johann Friedrich Böttger (1682–1719) in collaboration with Ehrenfried Walther von Tschirnhaus (1651–1708), court scientist to Augustus the Strong, in the first years of the eighteenth

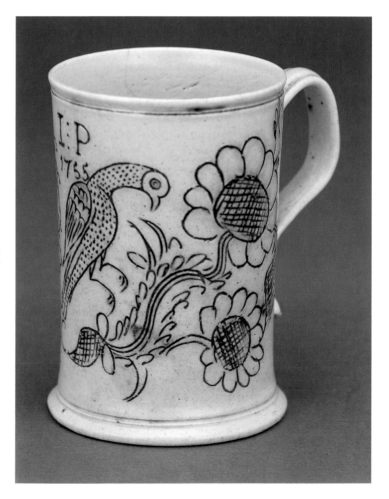

STONEWARE: SCRATCH BLUE
Mug. English
(Staffordshire), inscribed
IP, dated 1755. Stoneware,
H: 9.5 cm (3¾ in.); W (incl.
handle): 9.2 cm (3⅝ in.).
BM, MLA 1887, 2-10, 171.

century. The recipe, consisting of colored clays fused with loam, resulted from their attempts to produce porcelain at MEISSEN, future home of the Royal Saxon Porcelain Manufacture.

Caneware, buff or tan dry-bodied stoneware first developed by Josiah WEDGWOOD in the late eighteenth century. Subsequently produced in the factories of John Turner (died 1786), Josiah Spode (1755–1827), Enoch Wood (1759–1840), and others, caneware was especially suited for fine and detailed decoration because of the smooth and fine-grained character of its body. It was used to produce a variety of tablewares as well as figures and was occasionally embellished with ENAMELS or smear glazes.

Dry-bodied ware, all unglazed stoneware embellished solely with the addition of metal oxides or colored clays to the body, including Böttger red; caneware; Wedgwood basalt, jasperware, and *rosso antico*; and BISCUIT STONEWARE.

Ironstone, opaque, heavy, and durable stoneware first produced in England in the early nineteenth century and often decorated with blue printed decoration. The term is sometimes considered broadly synonymous with stone china.

Scratch blue and **scratch brown,** salt-glazed vessels dating from the mid-eighteenth century, decorated with scratched patterns, the incised cavities of which are filled with cobalt oxide (for blue) or manganese oxide (for brown) before firing. See also GLAZE.

Turner's stoneware, fine, white, porcellaneous ware usually decorated with TRANSFER-PRINTED CHINOISERIE patterns. Developed about 1800 by John Turner of Lane End, Staffordshire, to replace the less fine Chinese export porcelain of the time, it was renamed *stone china* in 1805, when the patent was sold to Josiah Spode.

TERRA-COTTA

(ITALIAN, "BAKED EARTH")

A lightly fired EARTHENWARE, usually red and unglazed. Sculptors often use terra-cotta to produce three-dimensional "sketches" and other sculptural objects, since the material is easily modeled and quickly fired. Terra-cotta is also commonly used for bricks and molded architectural ornament. It is rarely used for functional vessels, however, since the low-temperature-fired, unglazed material is too porous and friable to be practical.

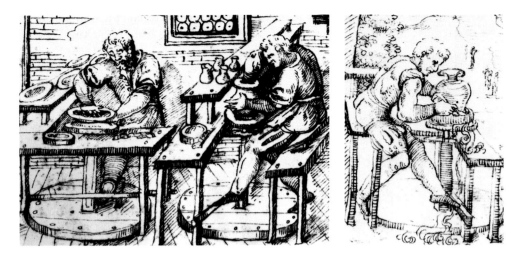

THROWING AND TRIMMING

Cipriano Piccolpasso (Italian, 1524–1579). *Throwing on the Potter's Wheel* (left) and *Trimming on the Potter's Wheel* (right) from *Li tre libri dell'arte del vasaio* (1557), fols. 16r and 19v.

THROWING

Forming a vessel on the POTTER'S WHEEL. A ball of clay is centered on the rotating wheel head or on a plaster BAT attached to the wheel head. The potter then forms the piece by exerting hand pressure on the spinning clay. Tools, especially *ribs* (also known as *palettes*), are often used in throwing. Originally made of animal ribs, these flat pieces of metal or wood have curved sides that help shape a vessel on the wheel. Small *sponges* can be used to clean the surface and add or take away water. Turning tools such as *wire loops*, *scrapers*, and *blades* can be used to help form the piece but are most often used to refine a shape by trimming or shaving a LEATHER-HARD piece that is reattached to the wheel after it has partially dried.

TORTOISESHELL WARE

See EARTHENWARE.

TOWING

Excess clay, seam marks, and rough edges need to be removed before the first, or biscuit, FIRING of a dried ceramic object, usually flatware such as plates. This can be done with sandpaper, tow (coarse hemp), flax or jute, or some other fine abrasive. A knife or metal tool is used in FETTLING for the same purpose.

TRANSFER GILDING

The same process as TRANSFER PRINTING, except that gold powder instead of ceramic color is used in "inking" the copper plate, the design of which is then transferred to an intermediate paper. The gold powder can also be dusted directly onto the surface of the

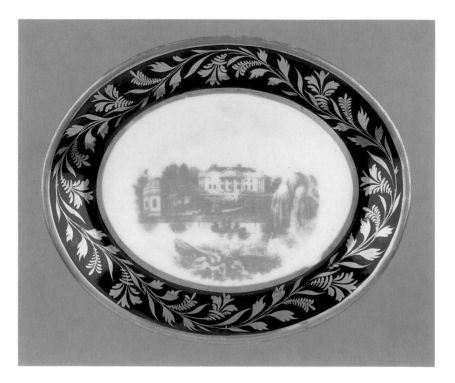

TRANSFER GILDING

Peter Warburton (1773–1813; Cobridge, Staffordshire). *Ovoid Teapot Stand*, c. 1810–12. Hybrid hard paste, L: 17.1 cm (6¾ in.). BM, MLA 1957, 12-1, 47.

ceramic after the design has been transferred from the paper. A transfer-gilding process was patented in England by Peter Warburton in 1810.

TRANSFER PRINTING

(TRANSFER DECORATION)

Rather than relying on hand-painted decoration on the ceramic surface, this method, possibly invented by the Irish ceramist John Brooks around 1753, uses a mechanical process in which the design is transferred from a copper plate inked with ceramic color to an intermediary surface, generally a piece of paper or tissue that, while still wet, is pressed or rubbed onto the ceramic surface, thereby leaving the inked design. In this way, designs can be easily reproduced, creating a uniformity in the level of production and thereby helping to keep production costs down.

Cold printing or *bat printing* was introduced in the eighteenth century. In this process, the copper plate is engraved with a series of small dots, called *stipples*, rather than lines. Generally, a BAT of soft glue or gelatin covered with a thin layer of colorless oil is printed, with the image from the copper plate inked only with

printing ink rather than ceramic color. The image can then be dusted with ceramic color and transferred while still wet to the ceramic surface, or it can be dusted after the transfer of the image onto the surface. The piece is then FIRED.

In *hot printing*, hot ink and a hot copper plate engraved with the design are used. The image is printed onto a piece of tissue paper that is then placed on the BISCUIT surface of the ceramic. The tissue paper is rubbed from behind, thereby transferring the image to the ceramic, which is then fired.

Transfer printing was in use at Battersea by 1753 in the making of painted enamels on copper. Its popularity quickly spread to other English factories producing ceramics, such as Bow, WEDGWOOD, and Worcester. CHINOISERIE designs were popular during this early period, generally being printed in monochrome colors such as blue or red. Polychrome colors were used with European-inspired designs during the nineteenth century. Many ceramic companies still use the technique.

TRANSFER PRINTING
Plate. English (Staffordshire), early 19th century. Pearlware, Diam: 17 cm (6¹¹⁄₁₆ in.). BM, MLA Hobson (1903), R 26D.

VARIEGATED WARE

(MARBLED WARE)

EARTHENWARE or STONEWARE displaying dappled, veined, or mottled colors, usually produced in imitation of natural stones. The polychrome effect can extend throughout the clay body by WEDG-ING different-colored clays together, in which case it is called *scrodled ware*. One popular example of scrodled pottery, *solid agate ware*, was developed in Staffordshire, England, in the mid-eighteenth century.

Variegated decoration can also appear only on the surface of the pottery by coating the wares with different-colored SLIPS—as in *surface agate ware*, also a specialty of the eighteenth-century Staffordshire potteries—or by SPONGING, dripping, or dusting the ceramic surface with different-colored GLAZES. Examples of variegated glazed pottery include *clouded ware*, *granite ware*, *splashed ware*, *tortoiseshell ware*, and *Whieldon ware*.

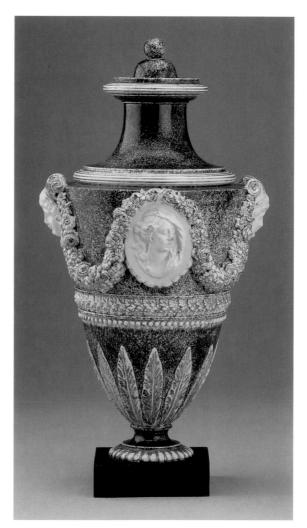

VARIEGATED WARE: GRANITE WARE
Vase. English (Wedgwood), c. 1769. Creamware, H: 31.8 × 15.9 cm (12⁷⁄₁₆ × 6¼ in.). BM, MLA Hobson (1903), I 782.

84

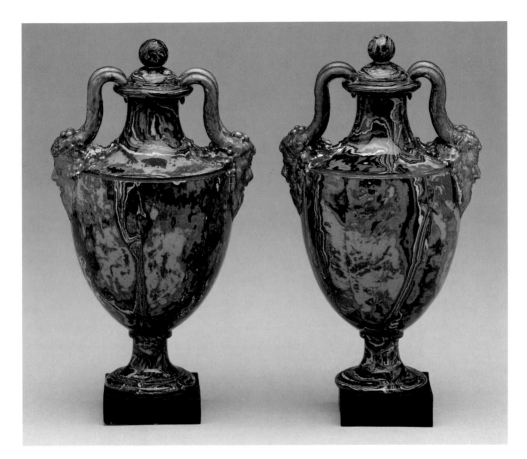

VARIEGATED WARE: MARBLED WARE
Pair of Vases with Satyrs' Masks. English (Wedgwood), 1769–80. Creamware; left, H: 30.5 cm (12 in.), W (incl. masks): 16.1 cm (6⅜ in.); right, H: 30.5 cm (12 in.), W (incl. masks): 15.8 cm (6¼ in.). BM, 1909, 12-1, 443.

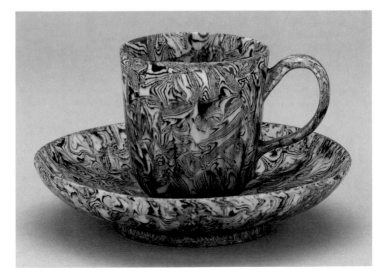

**VARIEGATED WARE:
SOLID AGATE WARE**
Cup and Saucer. English
(Staffordshire), mid-18th
century. Lead-glazed
earthenware, H: 7.5 cm
(2¹⁵⁄₁₆ in.); Diam (saucer):
12.9 cm (5¹⁄₁₆ in.). BM,
MLA 1923, 1-22, 18.

VENT-HOLE

Joseph Edgar Boehm
(Austrian, 1834–1890).
*Bust of William Ewart
Gladstone*, 1879. English
(Wedgwood). Parian ware,
H: 28.7 cm (11 5/16 in.);
W (across shoulders):
22.5 cm (8 7/8 in.). BM,
MLA 1979, 10-6, 1.

A small vent-hole behind
the neck and a larger one
between the shoulders
allowed gases to escape
from the interior of this
sculptural portrait bust
during FIRING.

VENT-HOLE

Opening or hole in the body of a ceramic figure or behind mask
handles through which gases escape while the piece is being
FIRED. Also, apertures in the KILN that can be opened or closed to
adjust the kiln atmosphere. See also REDUCTION.

WASTER

Defective ceramic piece, usually the result of deep FIRE-CRACKS or
deformed by excessive heat in the KILN, which is unusable and
must be discarded. Found on kiln sites, wasters can provide valu-
able archaeological information regarding the date and origin
of wares.

WASTER

Waster Fragments. French
(Savignies), late 15th–early
16th century. Stoneware,
max. Diam: 11.5 cm
(4 1/2 in.). BM, MLA 1963,
12-2, 8, 9, 13, 14.

WEDGING	Kneading of plastic clay, originally done with the feet, now most commonly achieved by hand or mechanically, which rids the clay of air and amalgamates the body into a homogenous mass. By hand, large pieces of clay are usually thrown into one another on a table, where the mass is cut with a wire between throws and then rejoined. This process is repeated until a plastic mass, free of air bubbles, is obtained.
WEDGWOOD	Josiah Wedgwood (1730–1795) was probably the most famous and innovative English ceramist during the second half of the eighteenth century. He was born into a family of potters who taught him his trade, and after a partnership with Thomas Whieldon of Fenton Vivian (1719–1795), he founded his own company in 1759. He experimented a great deal with GLAZES, ceramic bodies, and pastes. One of his earliest successes was *Queen's ware*, an easily manufactured and inexpensive EARTHENWARE with a cream-colored body and a brilliant lead glaze that was named after Queen Charlotte, who had admired it. It was an instant success, so much so that Wedgwood was commissioned in 1773 to produce a 952-piece service of Queen's ware for Catherine the Great, thus confirming his already well-established reputation. (Most of this service survives in the State Hermitage Museum, St. Petersburg, where a portion of it is on display.)

In 1769, Wedgwood formed an association with Thomas Bentley, a Liverpool merchant, which lasted until Bentley's death in 1780. During this period, their company began copying vases and decorative wares of classical inspiration, either directly from works borrowed from famous collectors for this purpose or from published sources. Some of these earlier vases were produced in a black STONEWARE, which Wedgwood called basalt. Though stoneware was already known to Staffordshire potters, Wedgwood perfected it to produce a silky-smooth surface that his painters could decorate with red figures in imitation of Greek originals. He also produced basalt plaques and busts of classical and contemporary poets and authors.

Jasperware is probably the ware most often associated with Wedgwood's name. It is a fine-grained stoneware that is colored throughout the body, with blue, green, and lilac being the most popular hues. Classically inspired molded white decorations are attached to the colored ware with SLIP, which, when fired, permanently fuses the two clays. The colors were admirably suited to the classically inspired interiors being designed by Robert (1728–1792) and James (died 1794) Adam. Wares ranged from small plaques used for buttons, to larger plaques used in decorating

architectural interiors or even furniture, to decorative vases that were sometimes made in sets. Wedgwood produced other unglazed stoneware, the most important being caneware, a buff yellow ware often made to imitate bamboo, and *rosso antico*, whose designs were inspired by Egyptian prototypes.

Mainly reproducing the wares that had made it famous a hundred years before, the company experienced financial difficulties during the first half of the nineteenth century. For a short time, it

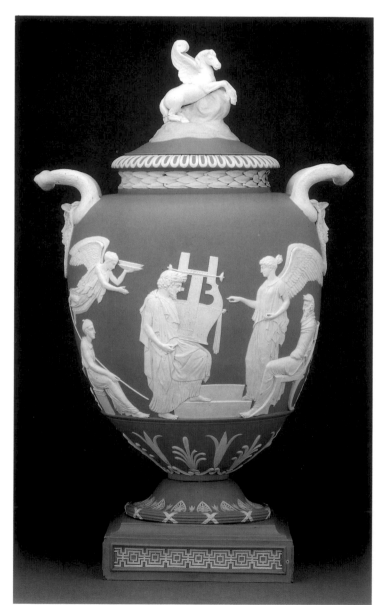

WEDGWOOD: JASPERWARE
Pegasus Vase. English (Wedgwood; frieze modeled by John Flaxman [1755–1826]), c. 1786. Jasperware (stoneware), H: 46 cm (18 in.). BM, MLA Hobson (1903), I 71.

even produced PORCELAIN. It was only toward the second half of the nineteenth century that Josiah Wedgwood's products were again avidly collected. The company's twentieth-century products are also sought after, in particular the "fairyland" luster decorated by Daisy Makeig-Jones (1881–1945) during the late teens and 1920s, and the more austere designs produced by Keith Murray (1892–1981) in the 1930s.

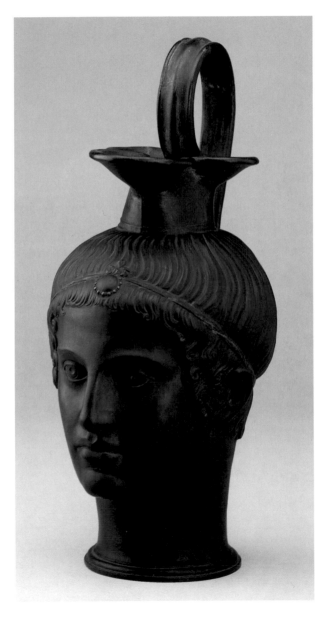

WEDGWOOD: BASALT
Head Vase. English (Wedgwood), late 18th or early 19th century. Black basalt (stoneware) with traces of bronzing, H: 28.7 cm (10½ in.). BM, MLA 1909, 12-1, 106.

WELL

See PLATE.

WHEEL-ENGRAVED DECORATION

Designs produced with the use of a gem-cutter's wheel incising the surface of the pottery. The best results are obtained when the body is extremely hard. Some of the most famous examples were produced by Böttger at MEISSEN, whose early red STONEWARE was ideal for this type of decoration. The decoration could either be cut into the surface, producing an intaglio design, or carved in relief by cutting away the surrounding areas.

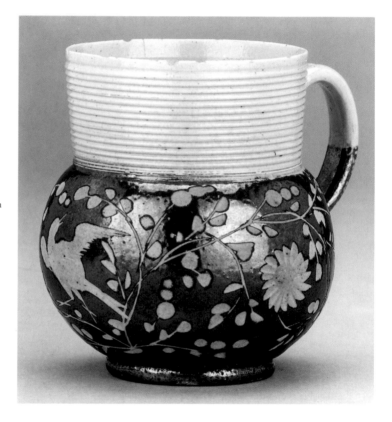

WHEEL-ENGRAVED DECORATION
Mug. English (Nottingham), c. 1710. Gray-white stoneware with brown glaze, H: 9.3 cm (3¹¹⁄₁₆ in.); Diam (incl. handle): 10.5 cm (4⅛ in.). BM, Hobson (1903), F 43.

WHIELDON WARE

See EARTHENWARE.

WHITEWARE

See BIANCO DI FAENZA and BLANC DE CHINE.

Caiger-Smith, Alan. *Lustre Pottery.* London, 1985.

————. *Tin-Glazed Pottery.* London, 1973.

Dawson, Aileen. *Masterpieces of Wedgwood in the British Museum.* London, 1984.

Haggar, Reginald George. *The Concise Encyclopedia of Continental Pottery and Porcelain.* New York, 1968.

Hamer, Frank. *The Potter's Dictionary of Materials and Techniques.* London and New York, 1975.

Honey, William Bowyer. *European Ceramic Art from the End of the Middle Ages to about 1815.* London, 1952.

————. *French Porcelain of the Eighteenth Century.* London, 1950.

Lane, Arthur. *Italian Porcelain.* London, 1949.

Lockett, Terry A., and Pat A. Halfpenny, eds. *Stonewares and Stone Chinas of Northern England to 1851.* Stoke-on-Trent, 1982.

Morley-Fletcher, Hugo, and Roger McIlroy. *Christie's Pictorial History of European Pottery.* Englewood Cliffs, N.J., 1984.

Piccolpasso, Cipriano. *The Three Books of the Potter's Art,* translated and introduced by Ronald Lightbown and Alan Caiger-Smith. London, 1980.

Savill, Rosalind. *The Wallace Collection : Catalogue of Sèvres Porcelain.* London, 1988.

Walcha, Otto. *Meissen Porcelain.* New York, 1981.

Wilson, T. H. *Ceramic Art of the Renaissance.* London, 1987.

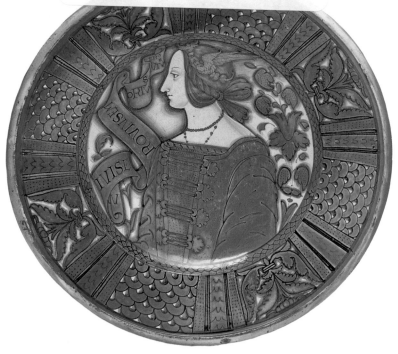

Lustered Display Plate with Female Bust (Piatto da Pompa). Italian (Deruta), c. 1500–30.
H: 8.8 cm(3½ in.); Diam: 42.8 cm(16⅞ in.). JPGM,84.DE.110.

John Harris, Editor

Kurt Hauser, Designer

Amy Armstrong, Production Coordinator

Jack Ross and Peter Stringer, Photographers

Eileen Delson, Production Artist

Typeset by Wilsted & Taylor, Oakland, California

Printed by Amilcare Pizzi S.P.A.